ONPRINT

from the screen to paper and vice versa

Laia Blasco Soplon

OnPrint from the screen to paper and vice versa

© 2011 by Index Book S.L.
Consell de Cent 160, local 3
08015 Barcelona, Spain
Tel. +34 934 545 547
Fax. +34 934 548 438
ib@indexbook.com
www.indexbook.com

ISBN: 978-84-92643-29-5

Publisher: Sylvie Estrada
© Text: Laia Blasco Soplon

Editorial coordination: Neus Bas
Art director: Laia Blasco Soplon

Layout: Andrea Espadinha / Ivana Kábelová
Illustrations: Eugènia Trallero / Núria Palacín
Photographs: Fotolia / Index Book archive
Translation:
- Chapter 1: Kelly Dickeson
- Chapter 2: Timothy Barton
- Chapter 3: Timothy Barton
- Chapter 4: Timothy Barton
- Chapter 5: Timothy Barton & Kelly Dickeson
- Chapter 6: Kelly Dickeson
- Chapter 7: Kelly Dickeson & Steven Capsuto
Proofreading: Steven Capsuto & Timothy Barton

English edition coordinator: Timothy Barton (www.timtranslates.com)

Printed in China

1. INTRODUCTION PRINTING YESTERDAY AND TODAY

1.1. From the screen to paper

'From the screen to paper'

Throughout history, the composition tools used by **graphic designers** have evolved. Nowadays, it's no surprise that designers' **main tool** is the computer, or that the main interface they use to view their work is the **screen**. Since the origin of the profession, the mission of the graphic designer was to express, on a physical medium – usually paper – a visual message made up of text and/or images. Today, however, graphic designers are responsible for composition not only on physical media such as paper, but also on media of other sorts, such as computer screens and mobile telephones. This book will basically describe **what happens to documents for print publication from the time they are originally designed on the screen to when they are printed on paper**, and will address issues such as how to go from the screen to paper without a hitch, how to set up files, how to edit files, and the possibilities offered by the various printing systems and finishes. The chapters that follow will explore these topics in greater detail.

'From paper to the screen'

The rapid development of computer technology – and in particular the expansion of the Internet – has given rise to new languages of communication. **Graphic designers** no longer just create print products; in addition, they must **know how to handle many other types of communicative objects** designed for other sorts of media. Nowadays, **new visual codes** allow for new representational possibilities (video, audio, animation, etc.), but we must remember that **these codes draw on classical, paper-based communication.** This context gives rise to questions such as: **What is the relationship between new media and print production? What will the future of this industry look like?** How has multimedia publication influenced printing? How has

traditional paper publication affected today's on-screen publishing? This book is also intended to shed light on all of these questions.

1.1.1. Chapters of this book [1]

1) Introduction: printing yesterday and today
The historical context of print production, from its origins to the present day.

2) The graphic production process
An overview of the stages, tools and professionals involved in print production: from the design to the product.

3) Prepress
Information about properly preparing and editing digital documents prior to printing.

4) Printing systems and media
The characteristics of the various printing systems and their possibilities and limitations with regard to the most widely used substrates and inks.

5) Print finishing
Properties of the various finishes and finishing processes that can be applied to printed products.

6) Outsourcing and quality control
Factors to consider when revising the product before production of the final version.

7) Printed vs. digital publication
The relationship between print production and multimedia production, and some prospects for each. The historical evolution of print media goes hand in hand with the progress

1. See Index

1.2. A brief history of print media

A medium is the vehicle used to transmit a message to its recipient.

of the media in general. As they developed, it gradually became possible to disseminate images, text and other content more widely.

1.2.1. The first media: painting and calligraphy

The oldest **cave paintings, which date back 40,000 years**, represent the dawn of visual communication by means of pictograms. Over the centuries, painting and drawing evolved to become not just a form of artistic expression but also the only means of immortalising images and representing reality.

The **fourth millennium BC** saw the emergence of the **first writing systems**: the cuneiform scripts of the Sumerians and Mesopotamians. Egyptian hieroglyphics appeared around 3000 BC, and the first Chinese scripts emerged around 1500 BC In different geographical areas, written symbols evolved through various stages – ideograms, phonemes, syllables, etc. – before developing into the alphabets we know today. Until the Middle Ages, the **literacy level** of the population was **practically zero**. The only means of reproducing text was that employed by monks: the **costly process** of patiently **copying manuscripts by hand**.

A scrivener transcribing a manuscript

In any case, **until 1400, communication** – whether **oral, written or painted** – was **always personal** or limited to a very small group of people. The reproduction of information was extremely expensive, and this made its dissemination practically impossible.

1.2.2. Chinese woodblock printing

Woodblock printing first emerged in China in the **6th century**. In this technique, the images or text to be reproduced are carved in relief into a block of wood, which is then covered with ink and stamped on paper. The earliest **movable type** systems, first clay and later metal, were invented in East Asia around the **11th century and in the 13th century**, respectively. The progress of these techniques stalled because the ideographic characters used in some Asian writing systems caused

problems. The oldest known printed book, from the year 868, is the 'Diamond Sutra'.

Stencilling (painting with templates), which first appeared in ancient China, Japan and Fiji, eventually evolved into another printing technique: **silkscreen printing**. This technique consisted of transferring ink through a silk mesh stretched over a frame; the image to be printed was formed by placing tree leaves across the mesh as a stencil. Silkscreen printing was usually applied to fabrics, murals or ceramics. It is sometimes referred to as serigraphy, from the Latin 'sericum', meaning 'silk', and the Greek 'graphe', meaning 'to write'. Silkscreen printing spread to Europe in around 1600, when the first works of Japanese art reached the continent. Artisans in certain parts of France started using the technique to print on fabrics, but its **widespread use on paper** and other media did not come about until the **early 20th century**.

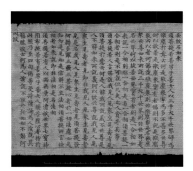

Diamond Sutra

Legend has it that the first meshes were woven from human hair.

1.2.3. Engraving in Europe

Engraving became popular **in Europe** in the **14th and 15th centuries** after paper-manufacturing techniques reached the continent from the East. [2] This printing technique consists of using sharp objects to carve an image into a hard surface, known as a matrix, which is later coated with ink and pressed against paper to make a print. Engraving techniques are referred to by different names (woodblock printing, linocut, chalcography, etc.) depending on the material used (wood, linoleum, metal, etc.). The most common technique was **chalcography**, in which metal plates were engraved by means of various methods (burin, drypoint, etching, aquatint, etc.). Once the image had been incised, ink was applied to the metal plate, including the incisions. The surface was then wiped clean prior to printing, so that only the ink deposited in the incisions would be transferred to the paper. Engraving made it quicker and less expensive to reproduce images and even some texts on what were known as **single leaves** .

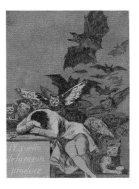

The etching The Sleep of Reason Produces Monsters, Goya, 1799

2. See 4.2.1.1. page. 137

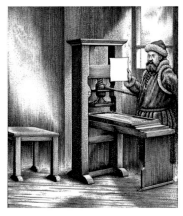

Gutenberg and his printing press

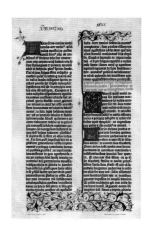

The Gutenberg Bible

Movable type

1.2.4. Gutenberg and the printing press

In **1449**, **Johannes Gutenberg** of Germany invented the printing press and published the world's first letterpress book: the Constance Missal. Gutenberg's major achievement was to design **movable type**: – individual cast lead pieces of type each bearing a character from the Latin alphabet in relief.

Lines of text were created by placing pieces of type next to each other in row after row, until a printing matrix representing a single page of a book had been assembled. With **Gutenberg's printing press** (itself an adaptation of early screw presses used to press wine grapes), each printing matrix was inked using a leather ink pad and then pressed against paper, leaving the image of a page of text.

This invention made it possible to **reproduce text** more easily and create as many copies as desired. Moreover, it allowed the **reuse of movable type**, since each printing matrix could be taken apart and the individual characters could be recovered.

Used in conjunction with existing illustration engraving techniques, Gutenberg's printing press revolutionised the dissemination of written information, giving rise to the **widespread publication of books**.

1.2.5. Lithography and photoengraving

Lithography was invented in **1796** when **Aloys Senefelder**, also of Germany, began experimenting with polished stone slabs. Using the well-known principle of **mutual repulsion between oil and water**, Senefelder drew an image on a smooth stone surface using an oil-based pencil and then washed the surface with water. When he did this, the porous areas were permeated by the water, but the oily areas stayed dry. When he applied ink, it adhered only to the oily areas of the stone, and this allowed him to transfer the image to paper.

A short time later, the heavy polished stone slabs were re-

placed by **flexible metal plates** coated with an emulsion; these plates could be wrapped around a cylinder and used on a rotary printing press instead of on a flat press. Lithography gradually became popular with artists, and the technique gave rise to the illustrations and caricatures characteristic of the era's periodicals.

The invention of **photography** revolutionised the world of image and communication by enabling **the reproduction of images taken directly from the real world**. The development of **photoengraving** techniques made it possible to transfer a photographic image to a printing matrix (either lithographic or chalcographic) and then to paper. By photographing the subject through a mesh filter, various shades of grey could be obtained during printing; later, using colour filters, it became possible to reproduce colour photographs. Several important figures developed **procedures for reproducing and printing photographic images.** : Poitevin invented photolithography in 1867, Firmin Gillot invented paniconography in 1850 and Charles Gillot invented a photoengraving process for photographic images in 1878. In 1890, Frederick Ives developed a system in which the entire prepress process was photographic and colour-based.

The first **offset lithographic printing press** was introduced in **1904**. The offset innovation is attributed to an error: a printer reportedly forgot to load a sheet of paper between the metal cylinder and the rubber roller of a rotary printing press. He discovered that the printed image came out sharper when it was transferred first to the rubber and then to the paper than when printed directly from the metal cylinder.

Despite its advantages, offset lithography combined with photoengraving techniques had one major drawback: in order to print an image with text, the set type had to be photographed and then a lithographic plate had to be made from the photo; the upshot was that **letterpress printing remained less expensive.**

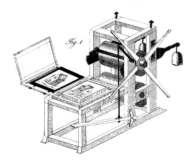

The lithographic printing press

Photography, which means 'writing with light', was invented by French business partners Niépce and Daguerre. In 1839, Daguerre developed the first practical method for recording an image on a medium.

Early 20th century photoengraving workshop

The compositor was the printing official responsible for composing the movable type

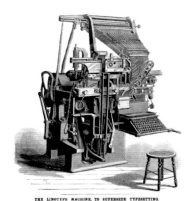

THE LINOTYPE MACHINE, TO SUPERSEDE TYPESETTING.

Linotype

A line of linotype

1.2.6. Advances in letterpress printing: Linotype and Monotype

In **1886**, the first **Linotype** was installed at the 'New York Tribune'. Invented by **Ottmar Mergenthaler, a German-born American, this machine** mechanised the typesetting process. The machine operator would use a keyboard similar to that of a typewriter to select particular typographical characters. When a key was pressed, the machine would release a matrix (the mould for a particular letter) from an overhead magazine into a rail, where it would be put together with other letters to form the words and spaces typed by the operator from a handwritten text. Each time the operator completed a line of text, it would automatically be sent to the casting section of the machine, where it was filled with molten lead to create a single piece, known as a slug, which represented the full line of type. After the matrices were used to cast a slug, the machine would collect them and return them to their respective channels in the magazine, where they would remain until the operator once again pressed the corresponding key.

In **1890**, **Tolbert Lanston** invented the **Monotype machine.** Using a keyboard similar to that of the Linotype, the Monotype operator would generate a perforated paper tape, which was then used to cast **individual pieces of type** in the correct sequence, thus forming a complete line of text. This machine made it possible to correct typographical errors manually by removing the incorrect piece and inserting the correct one, without having to re-cast the entire line.

Both the Linotype and the Monotype greatly sped up **typesetting**, which had previously been done entirely by hand. With these two machines, the process could be done at the speed of typewriting. **Letterpress printing**, combined with illustrations (photoengravings, lithographs or original photographs), emerged as the **main printing technique of the period**.

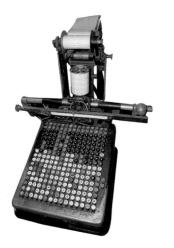

Monotype

1.2.7. From graphic arts to graphic industries

The **Industrial Revolution**, which began in the mid-18th century, brought about major technological, economic, social and cultural transformations in Europe. The invention of the **steam engine** accelerated the industrialisation process, shifting the economy away from manual labour and towards industry and manufacturing. **Rail transport** enabled the expansion of trade and the migration of the rural population to cities, thereby contributing to the emergence of two new social classes: the **industrial proletariat and the bourgeoisie.**

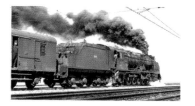

Steam locomotive

Not all sectors became industrialised at the same time. Textiles and metallurgy were affected first, but eventually all branches of industry underwent the inevitable revolution.

The graphic-arts sector introduced **steam-powered presses in 1814**. Throughout the 19th and 20th centuries, numerous technological advances helped printing evolve **from craft to industrialisation:**

- In 1865, the first **rotary presses appeared**.
- The Czech artist Karel Klíc invented **photogravure** in 1879 (a technique that involves incising a design onto large metal cylinders rather than flat plates, thereby allowing greater automation than with traditional engraving).
- **Photoengraving** and **lithography** proliferated as means of reproducing images and drawings in the mid-19th century.
- Towards the end of the century, typesetting techniques for letterpress printing improved with the invention of the **Linotype** and **Monotype machines** .
- The early 20th century saw the advent of **automatic book-binding** systems, which revolutionised a process that had previously been done entirely by hand.
- **Offset printing** was invented in 1904.
- **Flexography**, invented in France by Holweg in 1905, is a system based on letterpress printing that uses flexible printing plates instead of lead type.

- In 1907, Samuel Simon of Manchester patented the idea of arranging stencils on top of a silk mesh: thus was born the technique of **screen printing**.

By the early 20th century, the **graphic arts** had **become an industry**. Offset lithography, rotogravure and flexography were emerging techniques whose unique characteristics allowed them to occupy market niches, but they remained unable to supplant the lead-based printing press. Despite these advances, **letterpress printing** remained the **most widespread system** for reproducing text.

1.2.8. Phototypesetting and the offset printing boom

Offset printing finally supplanted letterpress printing in **1960** with the development of **phototypesetting and photomechanical printing**, which made it easier to reproduce images and text in a single printing system.

Phototypesetting emerged around 1960 with the arrival of the IBM Selectric typewriter, Letraset dry transfers, and the first phototypesetting machines introduced by the Monotype Corporation. In the 1970s, hybrid digital-mechanical typesetting systems, such as Linotype VIP and Compugraphic, came into common use in the production of text.

Having access to each series of a particular **type family** meant having each specific strip of paper or glass disk on hand. This was more convenient than the old lead type collections, but it still entailed considerable cost in terms of both money and storage space.

The most widely used **phototypesetting methods** involved a machine that resembled a keyboard attached to a black-and-white cathode-ray screen, which was used to enter coded instructions. When the operator entered **text** on the keyboard, the machine activated a **strip of paper** or a **glass disk** containing the entire alphabet for a series of a particular type family (Helvetica Bold, for example). When a particular key was pressed, that character was projected onto film, brought to the desired size using an enlarger, and photographed. Character after character was keyed in and photographed in

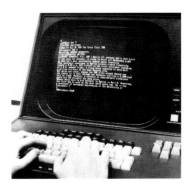

Screen and keyboard of a phototypesetter

this way until entire strips or columns of text had been assembled. In order to lay out a page, the film strips were then carefully cut and neatly pasted by hand onto transparent acetate film. Once the individual pages had been completed, they were carefully affixed by hand, one next to another, on another sheet of transparent plastic called a flat. In the phototypesetting system, page layout was done on **light tables**, which made it possible to line up the film negatives accurately and get good registration. The flat was then placed on a plate, which was exposed to a powerful beam of light inside a **plate burning machine**. The plate was then developed in a **plate processor**, where it was submerged in various liquids to remove the emulsion from the areas not intended for printing images.

Films of the pages of a publication arranged on a flat

The cameras used to photograph the **images** on film consisted of projectors equipped with **halftone screens**, which broke up continuous-tone images into very small dots, and **colour filters**, which separated the various colours onto different pieces of film (a necessary step for colour printing). These were known as **reprographic cameras**.

Reprographic camera

As we have seen, phototypesetting automated part of the printing process and **supplanted letterpress printing**, thus setting the stage for a boom in offset printing and other systems such as rotogravure, flexography and screen printing.

1.2.9. The development of computers and digital technology

It is hard to say exactly who built the first computer; it is certain, however, that from 1940 to 1980 a huge amount of research was carried out and great leaps were made in computers and computer science, improving the machines' performance and reducing their size at a dizzying rate.

The **1980s** saw the advent of **desktop publishing**, with the launch of PageMaker by Aldus Corporation in 1985 and the

Computer science is the set of sciences, techniques and activities related to automated information processing.

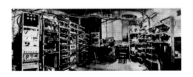

The Manchester Mark I, which began operating in 1949, was one of the world's first computers. It occupied an entire room and weighed several tons.

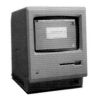

In 1976, Apple was founded, and the first Macintosh was launched in 1984.

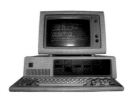

In 1981, IBM released its first personal computer (PC), which greatly popularised the use of computers.

Photoshop began as an application for Macintosh in **1987** under the name Display. **Adobe Illustrator** and QuarkXPress were both introduced the same year. InDesign, the main competitor to **QuarkXPress**, was not launched until 1999.

Digital photography

The first digital cameras were introduced around 1975, but they did not become widespread until the mid-1990s, when they became popular among both professionals and amateurs.

introduction of the LaserWriter printer for the Apple Macintosh. Desktop publishing would revolutionise the world of graphic design and prepress. Typesetting was done with an interface that was much more intuitive than that of phototypesetting machines, and users could **lay out text and images in a single interface**. The result was **digital page layout**, which produced a single film negative and made the tedious manual page-layout process unnecessary. The film negative would then be manually affixed to a flat, which was placed on a plate and put in a plate burner.

If **images** were to be added to a page in a desktop publishing program, they first had to be **digitised**. As a result of this need, the **digital scanner** – a device whose origins can be traced back to the 1960s – burst into high demand in the graphics industry. The first image ever scanned, in 1957, was a photograph of Russell Kirsch's son. In 1963, Rudolf Hell, who also invented the fax machine, developed a system called Chromacom, which was capable of scanning images in colour. In 1976, Ray Kurzweil introduced the first optical character recognition (OCR) device capable of scanning text and converting it into speech. Scanners were able to digitise images in black and white or in colour, and they could transform printed text into editable text. In the desktop publishing era, scanner skills became fundamental. A scanner operator needed a good eye and the ability to properly adjust RGB settings in order to faithfully convert an original image for subsequent reproduction.

With the advent of **digital photography** starting in 1990, the scanner played a less central role. The spread of digital cameras reduced the need to digitise images, which previously had always been in analogue form (slides or photo-

graphic prints). Having fallen steadily into disuse, scanners are nowadays used primarily to digitise hand-drawn images and other originals.

The development of **computer software** for the graphics industry continued apace. Programs for digital **image editing** (Photoshop), **vector graphics** (FreeHand, CorelDRAW, Illustrator) and **desktop publishing** (InDesign, PageMaker, QuarkXPress) proliferated. Advances in computer technology also led to the appearance of digital page **imposition programs**. With the arrival of computer applications capable of arranging the digital files representing pages in the correct places for subsequent filming, it was no longer necessary to manually arrange film negatives on a flat.

The mid-1990s saw the emergence of computer-to-plate (**CTP**) technology, which is capable of directly transferring an image onto a plate (or other printing matrix), thus eliminating the intermediate step of photographing the image and then transferring it from the film negative to the printing plate. In short, CTP bypasses the use of film.

The **computerisation of graphic techniques** also affected the operation of **printing machinery** (offset presses, rotogravure printing machines, flexographic printing machines, etc.) Printing mechanisms soon began to be handled by electronic devices that allowed greater control and precision and enabled them to be coupled to other machines involved in the printing process (binding machines, paper cutters, etc.). The development of new printing technologies eventually led to the appearance of **digital printing**, a process that **does not require any sort of printing matrix** – that is, the image is transferred directly from the digital file to the substrate.

Desktop publishing, together with advances in computer technology, transformed the **concept of typesetting**. In letterpress printing, each character was a piece of lead. Phototypesetting used strips of paper or glass disks. In the digital age, typefaces are files stored on a computer.

1.3. Current situation

The **graphics industry** is clearly undergoing a **transformation**. Some fear that printing will eventually be supplanted altogether by new media; others believe that the future will belong to the media that prove to be the most versatile. In any event, the printing sector clearly is reinventing itself to adapt to the constant and dizzying rate of change in today's world. The following sections describe some of the main **factors in the current situation**.

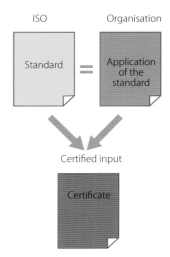

ISO publishes the standard, the organisation applies it and the certified bodies certify compliance with it

1.3.1. Technology and process

As explained above, **printing technologies** and **processes** have evolved greatly throughout history. Today we have digital originals, long-distance relationships via the Internet, computerised or fully digital printing systems, and task automation. The **following chapters** will analyse the details of today's printing processes.

1.3.2. Standardisation

The business world has seen a growing trend towards applying standards to a range of activities as a means of improving organisation and quality.

A **standard** is a document, approved by consensus by a recognised authority, that imposes rules, guidelines and characteristics to be observed by all parties involved, so as to optimise results in a particular area of activity. Standards offer a **procedural reference model** that organisations can follow by satisfying the technical specifications and requirements set out therein.

Standardisation is the process of drawing up, applying and improving standards that help to:

- **Simplify** reference models.
- Encourage **international exchange and communication**, which enable globalization and offshoring.
- **Rationalise** work in order to **optimise** production.
- **Guarantee the quality** of processes and products.

Accredited certifying bodies
By auditing processes, certifiers determine whether an organisation is following a particular standard.

ISO
The **International Organization for Standardization**, created in 1947, promotes the development of international standards.

The name ISO is derived from the Greek word 'isos', meaning equal.

Standards 3
ISO has developed close to 17,500 standards, with approximately 1,000 new standards being published each year. The printing industry follows generic standards that also apply to other sectors, as well as specific print-production standards that **provide the guidelines for today's work methods**.

1.3.3. Environmental concerns
The growing interest in sustainability has motivated the printing industry to try to minimise the environmental impact of print production.

The principle of the **Three Rs**, popularised by the environmental organisation Greenpeace, states: **Reduce, Reuse, Recycle**.

Forests
The production of the most common substrate – paper – entails the **threat of deforestation.**The implementation of **paper-recycling systems**, the production of recycled paper, and the use of wood from **managed woodlands** are popular measures now being taken to preserve the health of the planet's forests.

Energy
Another environmental concern linked to the printing industry is the energy consumed by the machinery involved in pre-

3. See 6.3.1.1. page 211

press, printing and print finishing processes (not to mention the machines that make the raw materials). The goal of **minimising energy consumption** can be achieved by **optimising the production process** and making improvements to machinery. These improvements may include **energy-saving systems** such as standby mode.

Waste

The waste generated by the graphics industry's many activities (gases, liquids, plates, film, proofs, etc.) leads to the release of various chemicals into the environment. Advances in chemical research have made available a growing number of **non-toxic products**. Likewise, new printing technologies have progressively **reduced the amount of waste generated** by the process.

Standardising environmental management

The **ISO 14001** standard is a set of documents that **evaluate the environmental responsibilities** associated with all aspects of managing an organisation. By following the standard, companies can integrate the environmental variable into all of their decision-making mechanisms.

1.3.4. New media

The rise of the **Internet** and the proliferation of **devices that can display digital content** have caused a paradigm shift in print production. This shift:

- Has introduced **new ways of communicating and relating with one another**. E-mail, FTP, web-to-print, etc., have simplified and sped up the information flow between designers and printers, shortened turnaround times, and promoted offshoring by making it possible to send files around the world in a matter of seconds. 👁️⁴
- **Casts doubt on the** traditional **concept of publication.** Whereas until recently publishing meant distributing

something using a medium such as paper, today the concept has been broadened greatly to include the dissemination of content via any sort of communications platform.

- **Has transformed the role of the reader or spectator into that of a user**. Rather than just receiving a message transmitted by an advertising agency, a publisher, etc., users are active: they interact, decide, influence and even generate information.

Just as the computer completely transformed the prepress process, new media are **poised to reinvent the printing industry**, transforming the business model in ways that we have only barely begun to understand today. **Where are we heading?** ☞ [5]

4. See 2.3. page 38
5. See Chapter 7, page 220

1.4. Summary diagram 1: The history of printing

The history of printing systems

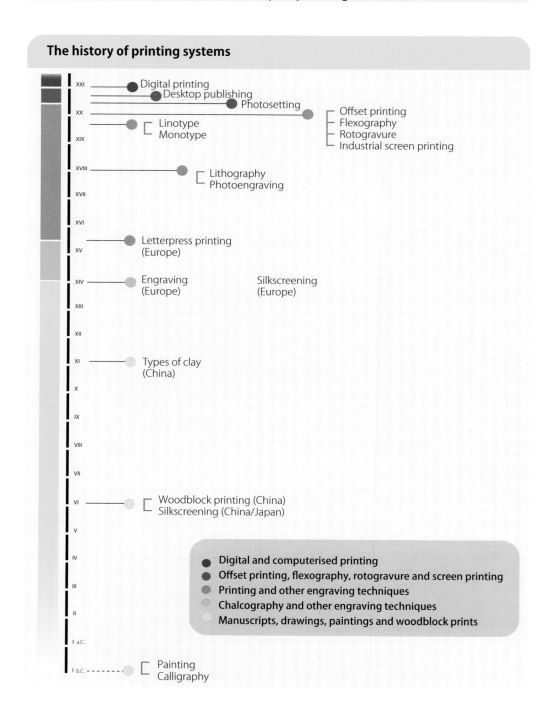

XXI	Digital printing
	Desktop publishing
	Photosetting
XX	Offset printing
	Flexography
	Rotogravure
XIX	Linotype / Monotype — Industrial screen printing
XVIII	Lithography
	Photoengraving
XVII	
XVI	
XV	Letterpress printing (Europe)
XIV	Engraving (Europe) Silkscreening (Europe)
XIII	
XII	
XI	Types of clay (China)
X	
IX	
VIII	
VII	
VI	Woodblock printing (China) / Silkscreening (China/Japan)
V	
IV	
III	
II	
I a.C.	
I b.C.	Painting / Calligraphy

- Digital and computerised printing
- Offset printing, flexography, rotogravure and screen printing
- Printing and other engraving techniques
- Chalcography and other engraving techniques
- Manuscripts, drawings, paintings and woodblock prints

Former prepress processes

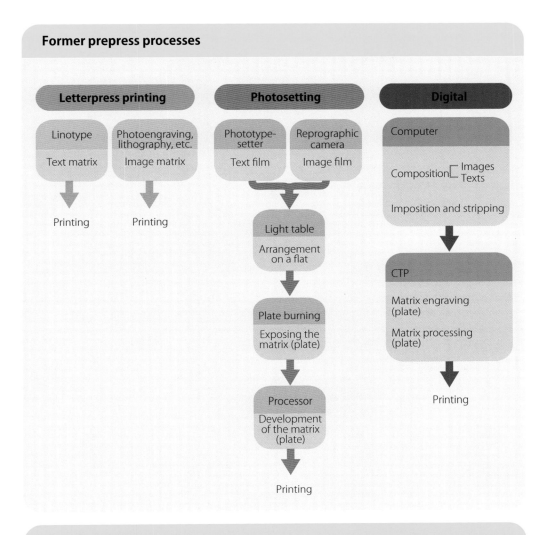

Letterpress printing

Linotype	Photoengraving, lithography, etc.
Text matrix	Image matrix
↓	↓
Printing	Printing

Photosetting

Phototype-setter	Reprographic camera
Text film	Image film

Light table
Arrangement on a flat

Plate burning
Exposing the matrix (plate)

Processor
Development of the matrix (plate)

Printing

Digital

Computer

Composition ⌐ Images
 ⌐ Texts

Imposition and stripping

CTP

Matrix engraving (plate)

Matrix processing (plate)

Printing

Printing today

The main factors that define printing today are:

- Printing technologies
- The application of printing standards
- Respect for the environment
- Coexistence with new media such as the Internet

2. THE GRAPHIC PRODUCTION PROCESS

2.1. From plan to product

When designing a graphic print product we are part of **a sequence that begins with the initial idea for the design and ends with delivery of the** finished product. When this idea is conceived during the initial creative phase when the project is first being developed, it is important to check that **the idea can be realised as a final product.** The designer must take into account the production process right from the beginning. The printing process consists of various phases involving **many tasks, professionals and tools.** By combining the characteristics of all of these, a thought, an idea, a plan can be turned into a finished product. Furthermore, designers who understand these properties can not only successfully avoid technical problems, but also significantly and creatively take advantage of the benefits to better transmit their ideas.

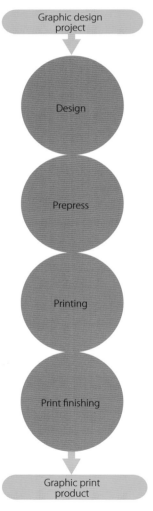

Graphic design project

Design

Prepress

Printing

Print finishing

Graphic print product

Phases of the process

The printing process involves combining tasks, professionals and tools.

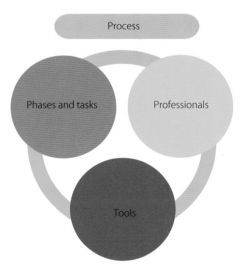

Process

Phases and tasks

Professionals

Tools

Communication is a vital factor in ensuring that the assembly line operates successfully. Good communication among the professionals enables the different parts of the production process to work well together.

Communication between the designer and printer (that is, the member of the print shop with whom the designer is in contact, whether that be a commercial agent, the manager or the prepress technician) is often not as fluid as it should be. There has long been a struggle between designers and printers, which often leads to misunderstandings and awkward, unproductive conflicts. **If the designer and printer strive for cooperation, trust and commitment to the project,** success is usually guaranteed, thus enabling the plans to materialise into well-finished products. The designer should consult **the printer** and trust the printer's experience, knowledge and advice. At the same time, **the printer should listen to**, digest and understand the designer's ideas and seek practical technical solutions to make the projects possible. The designer's and printer's active, creative involvement in a graphic design project makes for an efficient work team that infuses the project with anticipation and enthusiasm, ensuring a better final product and, no less importantly, helping to create a more pleasant, enjoyable production process.

Communication among the different phases of the production process is also vital. One should avoid working with distant departments or companies that carry out their task with little consideration for the other people involved. Those involved must remember that they are part of a process and that their phase is necessarily connected to other phases. Being aware of the problems in adjacent phases; seeking mutual understanding, respect and communication; taking into account what has been done and what will be done; facilitating the work in the next phase; being aware that one is part of a team: all of these improve the production process and help with achieving the common goal of creating a well-made product.

The following table lists the tasks carried out in each phase of the production process and states which professionals are involved in them. The table should be used only as a rough guide to the structure of an imaginary large business, that is, a business in which the roles are very compartmentalised.

In the graphics industry, **creativity** suffuses the entire production process, starting with the designer conceiving an idea and continuing with the printer seeking ingenious technical solutions. Cooperation between the two is essential for good results.

'**Professional creativity** means finding the right solution to the right problem at the right time.' Mariano Baños

We are all in the same boat and we are all heading to the same place: to make ideas reality and to obtain well-finished products!

2.2. Phases, tasks and professionals

| Design |
| Prepress |
| Printing |
| Print finishing |

Graphic design project → Conception of the idea → Graphic proposal → Texts / Images → Pages → Proofs → Original document → No printed product → Document editing → Proofs → Stripping - imposition → Proofs → Films → Image carrier → Conventional printing / Digital printing → Finishes and finishing → Delivery → Graphic print product

The various phases from the plan to the product.

But each organisation has a different structure depending on its size and nature, so each organisation may have its own variations with regard to the assignment of roles and tasks. **The size of the company affects the number of staff** in each phase and **the number of tasks undertaken by each member of staff**, with the possibility of a single worker having to carry out more than one role simultaneously. **The type of project**

also **affects which professionals will participate** and whether in certain cases external professionals need to be involved.

The design phase

The **idea** (what do we want to say?) is conceived, taking into account: Aspects such as the objective, the target audience, the price quote and the timing; The entire project and the production phases.	Art director and/or **Graphic designer**
Development of the graphic proposal (what does it look like?), taking into account: The composition of text and images; Assignment of responsibility for the required images and text; The production of the images (photographs, illustrations, etc.); The drafting and proofreading of text. Dispatch of **digital proofs** to the client and modifications. Preparation of **original documents**.	**Graphic designer** **Graphic designer** Illustrator Photographer Copy editor / proofreader **Graphic designer** **Graphic designer**
If the **graphic product will not be printed**, the process ends here. For certain types of products (multimedia objects), there is a subsequent production phase in the field of multimedia production.	(Programmer) (Developer)

Prepress phase

Preparation, editing, verification and certification of documents. Issue of proofs if there are corrections.	**Prepress copy editor**
Imposition	**Prepress stripper**
Making the **image carrier**	**Prepress stripper**
Proofs printed for the client	**Prepress colour manager**

The printing phase

Printing using the chosen system: offset, silk screening, flexography, rotogravure, digital printing, etc. (In this phase, the consequences of errors committed during the prepress phase appear. Depending on the type of error, the printing may need to be stopped and restarted from the preparation of the original document, resulting in lost time and money.)	Printer and assistants

Print finishing phase

Finishing and **finish**	Laminator Bookbinder Other finishers
Distribution to the client or users	Distributors

We will now describe in greater detail the roles of the graphic designer and the prepress technician. Most of this book deals with the tasks they carry out.

2.2.1. The graphic designer

The graphic designer is the professional responsible for **conceiving, programming, planning and carrying out visual** communications typically produced by industrial means and generally aimed at transmitting specific messages to specific segments of society. The graphic designer **represents ideas, actions and values graphically, enabling them to be communicated by constructing visual messages.** These visual messages can be channelled through many different media, including printing.

The **graphic design profession has changed** significantly. Not so long ago, not everyone had access to the work tools of a designer. Everything was done manually, or with expensive, complex instruments. The explosion in graphic software **gave everyone the possibility of having the tools** that a designer works with (who doesn't have Photoshop at home?), but that does **not** make **everyone a designer. It is not the tool that makes the profession.**

Graphic designers are professionals skilled in using graphics software, but more importantly they are **communication professionals who bear the production process in mind during the creation phase.**

2.2.2. The prepress technician

The prepress technician is responsible for **preparing the original documents of a graphic design to be printed.** This preparation includes: technical **editing** of the original document, **proofreading** and the final **imposition** for the size of the paper that will be fed into the machine, thus enabling the printing and finishing of the design.

The prepress profession has also changed greatly. Today we talk about editing of digital documents and we use the verb 'impose' to refer to the task of using software to arrange the elements as they should appear on the printing plate. A few years ago, the prepress technician had to manually compose the elements of each original page and manually assemble what today is done using imposition software. [1]

1. See 1.2.8. page 20

2.3. Interaction and communication flow

As stated previously, during the graphic production process there are various **tasks** that are grouped into several **phases** and are undertaken by different **professionals** using specific **tools**. These professionals communicate to exchange information, which means they need to remain in contact using **communication media.** The advent of **the Internet brought about a radical change in the flow of information, in the communication media and in the speed of work.** The Internet made it possible to send and receive data immediately and change the concept of distance. A designer can be in New York, have a client in Amsterdam and print some work in Barcelona, sending the files so that they are received instantaneously.

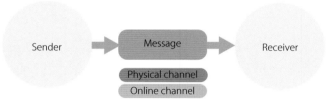

Outline of the communication process

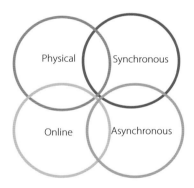

Synchronous and asynchronous physical and online communication

Synchronous physical
- visit
Asynchronous physical
- shipping, courier service
Synchronous online
- chat
- telephone
Asynchronous online
- e-mail
- FTP
- temporary file download

Much of the **communication in the printing process** takes place **online**: commissioning the work, sending the price quote, sending files, receiving proofs as PDF files, sending invoices, making payments, etc. Nevertheless, because this production process results in a **tangible product**, printing inevitably has a **material dimension** requiring physical interaction: transporting the raw materials, making the image carrier, finishing the printed material, handing over the final product, etc.

Online and physical interaction can be **synchronous** (sending and receiving take place at the same time) or **asynchronous** (sending and receiving do not take place at the same time). An organisation chart of the **interaction between the professionals** involved in the entire printing process of a typical

print shop reveals that **some interaction takes place online while other interaction inevitably requires physical contact.** Online interaction significantly speeds up working processes, but physical interaction is also very useful in certain circumstances. The latter is most effective when the designer needs to see samples, clarify queries or receive advice. **What is important is that in each case the best means of communication is identified.**

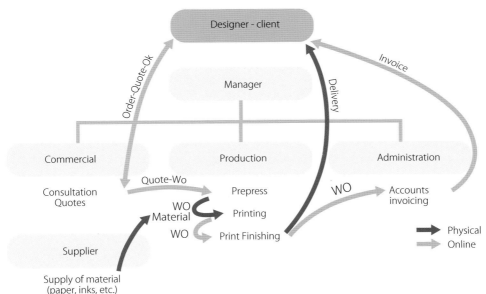

Overall organisation chart of the interaction at a print shop

A more detailed look at the flow of information and the online physical interaction in the **area of graphic design** reveals that interaction between designers and printers may take place solely online – by chat or e-mail – and by phone or fax, unless either a physical page design is presented, as is sometimes necessary to give an idea of what the final product will look like, or when a colour proof is made to check that the colour of the work will be printed as expected.

The commercial agent is the hinge joining together the designer and the print shop. The role of the commercial agent is essential in **interpreting the needs of the design, establishing delivery deadlines and coordinating** production. Far from being 'intruders', commercial agents should strive to **work alongside both the designer and the production team.** to enable the development of projects.

E-mail is the most widely used method for sending files. However, **very large files** accompanied by instructions or mock-ups that cannot be sent by e-mail are usually recorded onto a **CD, DVD or flash drive** and sent through a courier service or delivered in person.

When very large files are sent without a mock-up, **FTP (File Transfer Protocol) servers** are used. This network protocol enables files to be transferred between systems connected to a TCP (Transmission Control Protocol) network and is based on client–server architecture. A user on a client computer can connect to a server to download and upload files irrespective of the operating system used on each machine. The server administrator sets up folders that can be accessed with a username and password and that clients can access directly using their web browser or software such as FileZilla, Cyberduck, Fetch, Transmit and CuteFTP.

For large files, **temporary download links** produced by services such as Megaupload and MailBigFile can also be used. These webpages allow large files to be uploaded to a server, where they are stored for a limited period of time. The person receiving the file can initiate downloads by clicking on a link received by e-mail.

After this phase, the **prepress, printing and print finishing technicians must have physical contact** to exchange the image carriers, the material and the printed documents and to deliver the final product. The project instructions are described in a document called the **work order (WO)**, which covers the entire production and administration process from the price quotes to the invoice. Today, WOs are digital documents that are transferred from one professional to another through a business network. They are hosted on a shared server and can be edited by everyone.

2.4. Budget considerations

The **price quote** is a document detailing the cost of a service if it is carried out. The party issuing the price quote must stick to it, and cannot change it if the client accepts the service.

In the previous section on interaction and communication [2], we saw how one of the first contacts a designer has with the print shop is when **requesting the price quote**. The designer contacts the print shop by e-mail, by telephone or in person, generally via a **commercial agent** representing the print company. The designer must provide the agent with all the **necessary information** to calculate the cost of the potential project.

In order to explain the project's requirements and specifications, the designer must keep in mind the different aspects **of prepress, printing and print finishing** that we shall see throughout this book. The designer must also **listen and heed the advice** given by the print shop.

It is natural for the designer to ask for a quote from various print shops to **compare prices.**. However, the designer should ensure that the various quotes have been calculated based on the same characteristics (printing system, type of paper, finish, etc.). It is therefore essential for the designer to **specify all the items clearly and concisely**, not forgetting any, and to check that the characteristics of the price quotes match the specifications.

When requesting a quote, the designer must specify the following information, and should itemise the same on the invoice if the project goes ahead:

Type of product
What type of **product** it is: book, magazine, brochure, card, bag, etc.

Format and pages
Open and closed dimensions of the final printed item (in the case of folded or bound publications).
How many pages there are, if there is more than one[3].

2. See diagram page 39
3. See 4.2.1.3. page 140

Printing system

What the preferred printing system is: offset, screen printing, rotogravure, flexography, digital printing, etc. [4]

Inks and colours

The designer should state the inks used for printed items, specifying the **number of inks printed on each side** of the page and the colour reference of each ink.

- For example: A 4+4 (four-colour) item is printed on both sides with the four CMYK colours. A 2+0 (Pantone 201 and 208) item is printed on just one side with the indicated Pantone colours. [5]

Proofs

The designer must state **whether a proof is necessary**, what type of proof is necessary and what size it should be, bearing in mind that proofs generate an additional cost. [6]

Substrate and its characteristics

The designer must state the **substrate:** paper, plastic, fabric, metal, etc.

The designer must also state its **characteristics:** variety, colour, thickness, brand, weight, etc.

- For example: the designer must indicate the type of paper (coated, offset, adhesive, etc.) and its weight (100 g, 300 g, etc.). [7]

Finishes and finishing

What **finish** and **finishing** it will have: cut, varnished, laminated, die-cut, bound, etc.

If any kind of **coating** is required, the designer should state on **how many sides** the coating will be applied.

If the material will be bound, the designer should state what **type of binding** is required: stapling, perfect binding, stitching, hardback binding, etc. [8]

Number of copies

The number of copies required is one of the deciding factors for choosing one printing system over another.

4. See 4.4. page 156
5. See 4.3. page 150
6. See 3.10. page 126
7. See 4.2. page 136
8. See chapter 5, page 176

Depending on the printing system, **the designer should request a price scale** that covers various quantities to assess how much the relative cost of starting up the machine can be reduced. [9]

Packaging
Sometimes the designer should warn the printer that **certain packaging conditions are required:** special care for very fragile products, packaging of precise numbers of copies for various shipments, anonymous packaging (without advertising for the print shop), etc.

Delivery
The designer can indicate the **desired deadline** (which is always subject to negotiation with the print shop).
The designer should also indicate the place or places of delivery if transport is included in the quote.

Other
Depending on the type of project, the designer can add **other specifications**, provided that they help to clarify the potential job: a sketch or a low-resolution PDF file of the actual design, special payment conditions, etc. All indications should be clear and concise.

9. See 4.4. page 156

2.4.1. An example of a budget request form

Name of job	Magazine 'Printing Today', issue 1
Type of product	Magazine
Format and pages	21x27 cm closed (vertical) 42x27 cm open 44 pages (including front covers)
Printing system	Offset printing
Inks and colours	Front covers: 5+4 (four-colour printing and Pantone 877 on the front side and four-colour printing on the back side) Inside: 4+4 (four-colour printing)
Proofs	A colour proof of the back-page advertisement (20x23 cm) is needed
Substrate and its characteristics	Front cover: 200 g solid matt paper Inside: 125 g solid matt paper
Finish	laminated 1 side, gloss UV spot varnish 1 side. Staple bound.
Number of copies	Price for 750 / 1500 / 2,000 copies
Packaging	250 copies packaged on one side, and the rest on the other
Delivery	Delivery deadline:10 days Deliver 250 copies to Madrid Deliver the rest to Barcelona

2.5. Tools: the computer and its devices

The main tool that the designer and prepress technician work with is the computer. The computer can be described as the **operations centre** where **information arrives** and is **processed**, and from which the processed information **leaves** and moves on to other tools that make the product a reality.

2.5.1. Computers

A computer is an electronic machine that **receives and processes data to convert them into useful information.** It is a collection of related components that, with great precision and speed and as instructed (by a user or automatically), can run a variety of sequences of instructions that are organised, systematised and transmitted using the programming languages and code underlying the computer programs.

Data: '(1) A series of observations, measurements, or facts; information. (2) Also called: information / computing the information operated on by a computer program'.

Information: 'The act of informing or the condition of being informed'.

Inform: 'To give form to'.

Computers need specific **data** that must be **supplied** and are known as the **'input'.** The computer calls the data during **processing** in order to provide the **final product**, which is referred to as the **'output'.** The resulting information can then be saved, used, reinterpreted, transferred or retransmitted to other devices that use different communication and storage systems.

In order to process the data, the computer needs **software** and **hardware**, as well as **input devices** for data input, **output devices** for data output, and **storage devices** for saving information.

2.5.2. Software

This is a computer's **intangible equipment**. Software comprises all the **logical components** necessary for tasks to be carried out.

A computer's basic software includes: **an operating system, utility software, drivers and applications.**

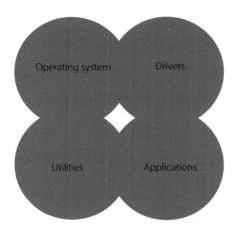

Types of software

Operating system

The operating system is a computer's fundamental software. It is a set of computing programs the purpose of which is to manage the resources, files, tasks and connections with peripheral devices. The operating system also provides the user interface, enabling communication between computer and user. The most common operating systems are Mac OS, Windows and Linux.

In graphic design and production, **Macintosh**. computers are the most widespread. Since 2006, these computers have been fitted with Intel processors, thus enabling both the **Mac OS and Windows**. operating system to be installed. This development brought Macintosh and PC computers closer together; reduced incompatibilities, which create difficulties; and brought graphic editing programs (which traditionally were more stable on Mac systems) and office programs (which traditionally were used only on PCs) together on a single computer.

Utility software

These are programs that work alongside the operating system to give it additional functions. Antivirus software, screensavers, print screen utilities and font managers are examples of utility software.

Drivers

Drivers enable communication between the computer and peripheral devices.

Applications [10]

Applications are programs that carry out functions within specific work areas. In graphic design, various types of applications are used, including:

- **Word processors:** production and editing of text.
- **Databases:** organisation of information for subsequent retrieval.
- **Image editing software:** image processing.
- **Illustration software:** creation of vector graphics.
- **Desktop publishing software:** layout of text and images to create pages.
- **Preflight software:** checking and proofreading original documents.
- **Imposition software:** stripping and page imposition.
- **Enterprise resource planning (ERP) or workflow software:** integration of all the system steps, such as calculating quotations, generating work orders, invoicing, implementing cost control, and applications involved in the administrative and production process (preflight, imposition, making the printing plate, colour tests, etc.).

iMac

2.5.3. Hardware

The hardware comprises all the **physical and tangible components** of a computer and its peripheral devices, including electrical, electronic, electromechanical and mechanical components.

The main hardware components are as follows:

Processor or CPU (Central Processing Unit)

The central unit, the component in a digital computer that processes data, interprets instructions, and controls all the functions of the software and the behaviour of the hardware components.

10. See 3.2.3. page 65

Data bus
Transfers data between the different hardware components.

RAM (Random Access Memory)
RAM is work memory where the processor receives instructions and saves results while the computer is operating. The contents of RAM are lost each time the computer is switched off.

ROM (Read Only Memory)
Used in computers and other electronic devices to contain the fundamental components of the operating system that do not require recent updates.

Mac Pro

Motherboard
A circuit board that holds and connects together the integrated circuits of the CPU, ROM and RAM.

Hard disk drive
A storage device used to save software data and files.

Mac Air

Video card
Sends data and controls how they are viewed on graphical output devices such as the monitor. Other types of cards also exist, such as sound cards, network cards, etc.

Communication ports
Communication interfaces that enable data to be transmitted between computers and peripheral devices. The main ports are:
- USB 2.0
- FireWire (400/800)
- Ethernet
- DVI
- VGA
- Audio input
- Headphones
- Phone line modem

Power supply unit
Circuit that converts the AC mains power to the voltage required by the computer.

Peripheral devices
Independent, auxiliary devices connected to the CPU through the ports. They are classified into input, output and storage devices, the most common of which are the monitor, the mouse and the keyboard, although in the graphics industry many other devices are used.

One megahertz (MHz) equals 1 million hertz (Hz). One gigahertz (GHz) equals 1,000 MHz. **The hertz** is a frequency unit in the International System of Units. A hertz represents one cycle per second, a cycle being the repetition of an event.

2.5.4. Computer speed

Three major factors dictate the speed at which a computer can run: the **processor speed**, the **data bus speed** and the **amount of RAM**. The processor speed determines the number of calculations per second that the CPU can achieve and is expressed in megahertz (MHz) or gigahertz (GHz). The data bus speed determines how quickly data are transmitted and is also expressed in MHz or GHz. The amount of RAM installed in the computer is also important since it determines how much data the machine can temporarily store, and therefore the amount of data with which it can work. It is expressed in megabytes (MB) or gigabytes (GB).

One megabyte (MB) equals 1 million bytes. One gigabyte (GB) equals 1024 MB. **The byte** is used as the basic unit for data storage and is a group of 8 bits.

The bit is a digit of **binary code** and is the smallest piece of data possible. A bit can be one of two values: 0 or 1.

2.5.5. Peripheral input devices

These are the devices that send data to the computer, thus supplying input. The most common input devices used in the graphics industry are:

Keyboard
A series of keys grouped according to their functions. The keyboard layout is based on the first typewriters. The USB port is usually used.

Keyboard

Mouse

A pointing device that detects two-dimensional movement of the mouse along a flat surface. The mouse enables the user to move around the user interface and select elements or options using up to two buttons (right and left) and often a scroll wheel in the centre. The USB port is usually used.

Touch screen with a light pen or graphics tablet

A device consisting of a pointer pen that is moved on a screen capable of detecting the pressure placed on the surface and the movement of the pen. This device enables the user to select objects and options with great precision and can capture the expressiveness of manual pressure in the drawing of illustrations. The USB port is usually used.

Graphics tablet and mouse

Scanner

A device that uses a beam of light to detect the patterns of lightness and darkness and/or colours of a physical, analogue image and converts it into a digital image that can be edited using image editing software, optical character recognition software, etc. With the advent of digital cameras, scanners are used less and less, and today they are used mainly to digitise physical original documents or manual illustrations. Desktop scanners can process most tasks, while high resolution scanners (flatbed or drum scanners) are used by companies specialising in image reproduction to digitise originals at a much higher resolution or larger size. The USB port or the Ethernet port is usually used.

Flatbed scanner

Drum scanner

Digital camera

A camera or video camera that stores images on an electronic device rather than on a film or tape. Digital cameras are connected to the computer and upload the images they have captured. There are many types of digital cameras with a wide range of characteristics that should be understood and mastered to achieve faithful reproductions. The USB or Fire-Wire port is usually used.

Digital camera

Webcam

A small camera that is connected to or is part of the computer. It is used to capture still or moving images, generally for transmission over the Internet.

Internet connection

Although not a physical device, this connection is used by the computer to receive data, and can therefore also be considered a data input device. The Ethernet port or WiFi connection is usually used.

Other possible input devices include microphones (audio input), barcode readers, joysticks, voice recognition, eye movement recognition, etc.

2.5.6. Output devices

These are the devices that receive the information processed by the CPU and reproduce it in a way that can be perceived by people, thus supplying output. The most common output devices used in the graphics industry are:

CRT monitor

Monitor

Screen showing the information supplied by the computer. There are two main types of monitors: CRTs (cathode ray tubes), which are very large, and LCDs (liquid crystal displays), which take up less space and are now the most widely used. Monitors must be calibrated to display colours properly. Not all monitors are the same, and the quality of the images they can reproduce varies. Those choosing a monitor should consider factors such as the screen resolution, dot pitch, screen size and refresh rate. Most screens use a DVI (digital video interface) or VGA (video graphics array) connection (except for laptop computers and computers with an integrated screen). ☞[11]

LCD monitor

Projector

Device that receives the signal from the computer and, using a lens system, projects the image normally seen on the monitor onto a projection screen or any other surface. The quality of the images it reproduces depends on its characteristics. Most projectors use a DVI or VGA connection.

Printer 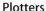[12]

Device that enables the images or text processed by the CPU to be reproduced on a physical medium (paper, plastic, CD, etc.). A virtual PostScript or PDF printer is also considered a printer. The USB or the Ethernet port is usually used. There are many kinds of printers, the most common of which are:

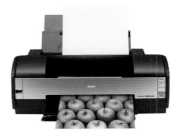

Inkjet printer

- **Inkjet printers:** These printers propel droplets of various sizes onto the paper.
- **Laser printers:** These printers are faster than inkjet printers. A photosensitive drum is linked to a toner reservoir and a laser beam that is modulated and projected.

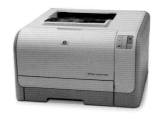

Laser printer

Plotters

These are large inkjet printers. There are also cutting plotters, which instead of printing cut shapes. The USB or the Ethernet port is usually used.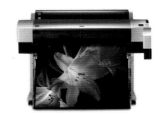[13]

Plotter

Raster Image Processor (RIP)

Converts the page description data (PDF or PostScript) into bitmaps so they can be reproduced via film, a plate, a photocopier, etc. The Ethernet port is usually used, as the RIP is usually connected to a network.

Internet connection

Although not a physical device, this connection is used by the computer to send data, and can therefore also be considered a data output device. The Ethernet port or WiFi connection is usually used.

CTP connected to a RIP

11. See 3.2.1. page 64
12. See 4.4.5. page 167
13. See 4.4.6. page 168

Other output devices include headphones or speakers (audio output) and fax capability.

2.5.7. Storage devices

These devices store processed data so that they can continue to be worked on or be sent to another device. Various types of storage devices exist:

Hard disk drive
A non-volatile storage device using magnetic technology, normally accompanied by a cooling fan.
Computer hard drives are integrated into the computer and have a capacity measured in gigabytes (GB) or terabytes (TB). There are also external hard drives with a variety of capacities (250 GB, 500 GB, 1 TB, 2 TB) that can be used both for working and for making backup copies. The USB port or the FireWire port is usually used.

External hard drive

One terabyte (TB) equals 1024 GB.

RAID storage systems are used for backup copies, storing information by dividing and replicating data among multiple hard drives. Their configuration, which is usually referred to as a level, determines the combination of disks that will be used.

Flash memory
Solid-state memories on which data are written and deleted using electrical impulses. Flash drives, or pen drives, are small flash memories that connect to USB ports and are used to transport files more easily.

CD-ROM (compact disc read-only memory)
A read-only write-once compact disc, meaning that data can not be rewritten on it (rewritable discs exist but are rarely used). The optical technology requires a laser beam and a photodiode for the data to be read. The storage capacity of CD-ROMs is approximately 700 MB. They require a CD burner for writing and a reader for reading.

DVD (Digital Versatile Disc)
Similar to a CD-ROM, but with a larger capacity of approximately 4.7 GB. DVDs require a DVD burner for writing and a reader for reading.

CD/DVD/Blu-ray

Blu-ray Disc

Another optical disc format in which the discs are the same size as CDs and DVDs. The format was designed for high-definition videos and high-density data storage. They have a capacity of 25 GB per layer, and therefore 50 GB for a dual layer disc. Discs with a higher capacity (up to 200 GB) also exist. A Blu-ray reader and burner are needed to read and write on the discs.

Internet connection

Although this is not a physical storage device alongside the computer, we can access storage devices in the form of **virtual disk drives available over the Internet:** web hosting services, FTP servers, e-mail accounts, etc. The Ethernet port or WiFi connection is usually used.

2.6. Workflow

Other storage devices that are hardly used at all today are diskettes and Zip drives. The memories of MP3 players, MP4 players and digital cameras can also be considered storage devices. The term 'workflow' refers to what we have seen in this chapter: **the process that is followed, from when the project is commissioned to when the product is released.** All print shops have a workflow. Some may have a better prepared, more optimised or more automated workflow than others, but all organisations have their method of managing the series of operations that are part of their system, and this method defines their workflow.

The explosion in companies certified with the **quality-management standard (ISO 9001:2001)** is evidence of the widespread concern for control of the process.

Although market demands for shorter deadlines are the result of many factors (technological improvements to machinery, improvements in telecommunications, etc.), **workflow optimisation** is known to be a key factor in **improving productivity** and therefore making a company more **profitable**.

Workflow applications automate the sequences of tasks that take place in a process. These applications include **status monitoring** of all the stages and aim to provide **integrated management. They bring people, tasks and machines together**, enabling work to be completed quicker and allowing for teams in different physical locations. The objectives are to:

- Reflect, mechanise and automate methods and the organisation of the system (quotes, orders, WOs, the image carrier, printing, finishing, delivery, invoicing, cost, indicator assessment, decision making, etc.).
- Relate all the stages of the system to one another.
- Establish mechanisms for control and monitoring of procedures.
- Distinguish between the method being used and the people carrying it out.
- Detect staff training needs.
- Support the business's re-engineering and innovation processes.
- Facilitate the exchange of information and decision-making of an organisation, company or institution.

A **flow diagram** is a graphical representation using specific symbols for the steps involved in a process. Flow diagrams are useful for making people aware of a system's process and enabling them to detect mistakes in its sequence and improve the system's organisation.

- Focus the company around customer service.

Some print shops link workflow software with **online production monitoring systems**, which enable the client to find out from the company website what phase the order is in, what its status is and what the expected delivery date is.

2.6.1. Job Definition Format (JDF)

This standard format enables **communication between the various phases and devices** involved in the printing process, thus supplying task automation.

JDF format

The JDF format holds **the necessary information for a product to be created**, from commercial aspects (delivery and payment deadlines) to aspects relating to binding (the type of covers, special material, etc.) and to design and production (number of plates, pages, sizes, dies, paper, etc.).

The format contains **information on the management and production** of a project from start to finish. Anyone participating in any phase of the creation of the product can use the file. Right from the start**, the designer can work with the original PDF,** which is sent to be printed by a JDF containing **the job characteristics.** These details are used to calculate a price quote and carry out production. As the project progresses, information sent by all the users and system devices is added until the project is complete. The specific details of each phase of the process can be retrieved at any time.

MISs (Management Information Systems) and **ERP systems** (Enterprise Resource Planning) are types of **workflow software to enable integrated management.** They can manage JDF files.

CIP4

is the organisation responsible for developing and maintaining the JDF format.

The format is based on **XML**, a language that enables all users and system devices to edit and read tags that describe the project. The **information** can be **written and read manually by users, or automatically by JDF-compatible devices** carrying out a particular task: export to PDF, management software, printing machines, binding machines, etc.

2.7. Summary diagram 2: The graphic production

From plan to product

Good communication and cooperation among all those involved in the graphic design project ensures that the shared objective is achieved: a good graphic design product.

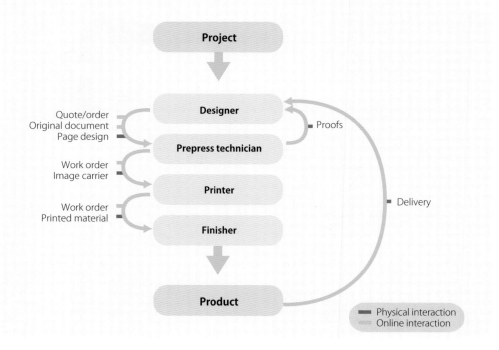

Quote and order

A quote needs to be clear, concise and detailed, and should specify the following:

- Name of job
- Type of product
- Format and pages
- Printing system
- Inks and colours
- If some kind of proof is required
- Substrate and its characteristics
- Finish
- Number of copies
- Packaging
- Delivery

The computer: the designer's and the printer's tool

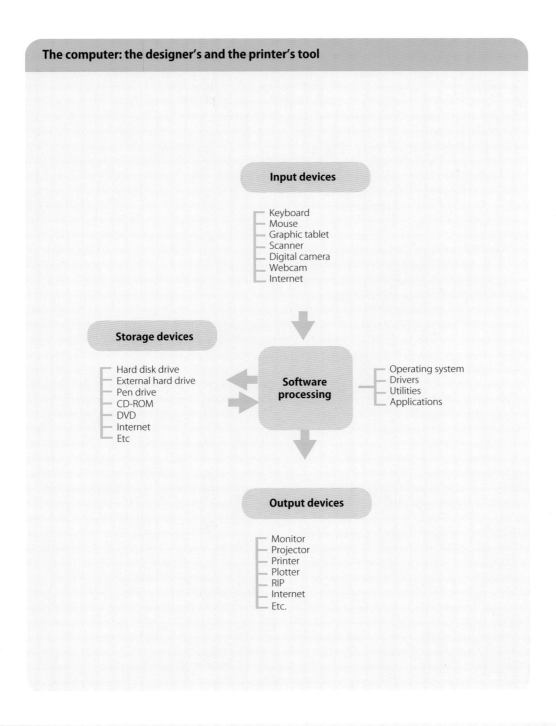

Input devices

- Keyboard
- Mouse
- Graphic tablet
- Scanner
- Digital camera
- Webcam
- Internet

Storage devices

- Hard disk drive
- External hard drive
- Pen drive
- CD-ROM
- DVD
- Internet
- Etc

Software processing

- Operating system
- Drivers
- Utilities
- Applications

Output devices

- Monitor
- Projector
- Printer
- Plotter
- RIP
- Internet
- Etc.

3. PREPRESS

3.1. About prepress

Prepress is, as its name indicates ('pre' means 'before'), **the process preceding the printing of the** graphic print product. In keeping with this definition, prepress **begins as soon as the graphic design idea is conceived**, before any computer program has been used. The prepress process must consider all the project variables that will enable the idea to become a tangible product.

According to the more technical meaning of the word, prepress encompasses **all the tasks carried out on a file so it can be printed and finished correctly.** From this perspective, prepress begins when a new file is opened in any computer program with the aim of producing a printed product. When a new document is created, and throughout the development of a design, as the images and text are being laid out, a series of parameters and technical characteristics that will affect the subsequent printing must be borne in mind.

When opening a new document in an application such as Illustrator, we must specify what format (width x height), colour mode (CMYK) and indentation we want.
Selecting the 'New' option of the 'File' menu in Photoshop allows the user to set the resolution that will be used. If these settings are not configured correctly, the material may not print as expected, and the user may even have to start the job again.

In InDesign, the user must also choose the size of the document and the indentation.

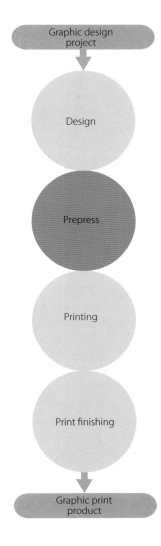

3.2. The working environment

Creating an appropriate working environment is important, as is having the working tools in the best possible condition.

Both the designer and the prepress technician work largely using their **eyesight**. It is therefore important to control the factors that affect how a design is viewed on the computer screen. That is where perception of colour comes into play. [1] **Each device displays colours differently,** and the colours are also **perceived differently depending on the light illuminating them.** It is important to **ensure the stability of the colours** so that those seen on the screen are as similar as possible to the final printed item. The calibration of the monitor and the ambient light should therefore be checked.

Eyeone

3.2.1. Calibration of the monitor
Although some tools included in operating systems allow the user to adjust the brightness, contrast or hue of the monitor, the best solution to calibrate the monitor correctly is to use specific **hardware and software that measure the colour projected by the screen**, enabling the user to adjust the values **according to the printed results.** Increasingly, these values are governed by **International Color Consortium (ICC) profile standards.** [2]

Monitors should be calibrated **regularly**; . The **quality of the monitor** affects the range of colours. Even with the best possible calibration on the best monitor that exists, **the colour displayed will never be exactly the same as the colour printed**, since the monitor produces coloured light whereas printers produce pigment colours.

3.2.2. Ambient light
Ambient light greatly influences perception of colour. Two identical objects of the same colour can be perceived as having two different colours if the lighting is different (this is known as **metamerism**). Neutral lighting is therefore recom-

1. See 3.5. page 94
2. See 3.6.7. page 107

mended. The colour effect of light emitted from a light source depends on its **colour temperature**, which is measured using the **Kelvin scale**. Lower temperatures increase the amount of yellow and red emitted, while higher temperatures increase the amount of blue. Neutral light is **white** and is the form of light most similar to the **natural light on a sunny day**. It has a temperature of around **5,500 K.**

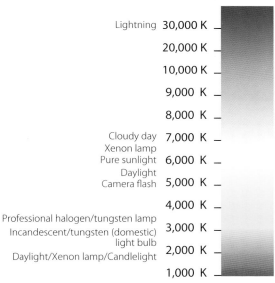

Lightning	**30,000 K**
	20,000 K
	10,000 K
	9,000 K
	8,000 K
Cloudy day	**7,000 K**
Xenon lamp	
Pure sunlight	**6,000 K**
Daylight	
Camera flash	**5,000 K**
	4,000 K
Professional halogen/tungsten lamp	
Incandescent/tungsten (domestic)	**3,000 K**
light bulb	
Daylight/Xenon lamp/Candlelight	**2,000 K**
	1,000 K

Colour temperature
Kelvin scale

ISO standards 3664 and 12647 define the criteria that standardised lighting equipment must fulfil. The most commonly used neutral light is **D50**, which has a colour temperature of **5,000 K.**

3.2.3. Graphic design applications

In chapter 2 we saw how applications are part of computer software, which is what most designers and prepress technicians use most of the time. We will now look at which specific applications are used in the printing process:

Proprietary software

In 2005 Adobe acquired Macromedia, which until then was its main competitor in the development of software for graphic

design. Since then, Adobe has been the main stakeholder in the graphic design market, owning software such as Photoshop, Fireworks, InDesign, Flash and Dreamweaver. The company continues to sell licences for its main programme, but it has begun to open up the specifications of its formats like SWF, FLV and PDF, especially since 2008, when it announced its Open Screen Project.

Open-source software

In addition to the Linux operating system, there are good open-source servers, programming tools, word processors, office applications, web browsers, etc. For graphics software, the Libre Graphics Meeting, an annual convention bringing together developers of open-source graphic design software since 2006, is particularly important for the promotion of projects and exchange of solutions. Xara, the company responsible for developing the vector software Xara Xtreme, and the Blender Foundation, which coordinates the development of the animation and graphics software 3D Blender, also play an important role, as do the development teams of programmes such as Gimp, Inkscape and Scribus.

The vast majority of companies involved in printed graphic production use the applications provided in **Adobe Creative Suite**. Nevertheless, open-source software is an alternative worth considering. The following table shows the most commonly used graphics software:

	Proprietary software	Open-source software
Office productivity applications	Microsoft Office (Word, Excel, Acces, etc.)	OpenOffice.org
Image editing	**Adobe Photoshop**	The GIMP (The GNU Image Manipulation Program)
Graphics editors	**Adobe Illustrator** Adobe Fireworks	Inkscape Xara Xtreme
Desktop publishing	**Adobe InDesign** QuarkXpress	Scribus

Photoshop, Illustrator and InDesign icons

3.3. Word processing

Text is one of the essential parts of a design. Leaving aside aesthetic aspects of text, there are a few technical aspects that designers preparing a file for printing should understand.

Texts are incorporated into designs as digital type. They can be digitised **by keying them in** or using **optical character recognition (OCR)**, in which an optical reader scans the text and recognises the characters, converting them into editable text; or they can be in a document created using a **word processor**, in which case they are already in a digital format.

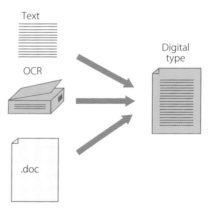

3.3.1. Editing and proofreading

Before being printed, all texts should be edited and proofread.

Types of editing
Technical editing: involves reviewing the original text to detect errors in the content. Technical editing should be done by a specialist with broad knowledge of the field.

Copy-editing: involves reviewing the original text to detect lexical and spelling errors. This should be carried out by a language specialist working in collaboration with the author.

Galley proofs are the proofs on which the typeset texts are proofread.

Proofreading: focuses on spelling and layout. Proofreading can be done by a prepress technician with good skills in spelling and layout. Spelling and grammar checking software is a useful tool for proofreaders.

3.3.1.1. Editing and proofreading marks

Certain symbols are commonly used by editors and proofreaders, some of which are shown in the table below:

Textual Mark	Correction	Marginal Mark	Textual Mark	Correction	Marginal Mark
wtten	Insert text	vi⁄	here. Speaking	Cancel indent	⌐
house or house	Delete text	⊢⁊ ⌐	here.	Wrong font	⊗ or wf
houuse	Delete character	⁄⁊	one, two & three	Equal spacing	⦀
super power	Close up	⌒	A good café	Leave unchanged	vale
super power	Delete and close up	⇕	Let's go outside	Left align	⊢
superpower	Full stop	⊙	We're waiting outside	Right align	⊣
here or there	Comma	⸒	café	Remove accent	7ˣ
below	Semi-colon	⋀;	mis aligned	Horizontal alignment	═
below	Colon	⊙	The sky is blue	Vertical alignment	‖
uneдr	Reorder	∽	200 m.	Spell out	metres
correct the order	Transpose characters or words	2↕3	Anglo Italian	Hyphen	hyphen
under	Italic	ital or ─	10 3=7	Hyphen-minus	minus
here or there	Roman	rom	under but	Em dash	em
under	Bold	bold or ∿	E=mc2	Superscript	⋎
under	Remove bold	fine	H2O	Subscript	⋏
Here or Here	Lower-case letters	lc or ≢	I cant do it	Apostrophe	⋎
october	Capital letters	C.A. or ≡	What? he said	Quotation marks	⸢« ⸣»
october	Small capital letters	sc or ═	the number one	Brackets	⊤(⊥)
October	Increase space	more	the number one	Square brackets	⊤⊏ ⊥⊐
a priori	Insert space between words	#	born in 17966	See original text	see org
here Start	New paragraph	⌐ or ⁊	5xt=t5x	Consult the editor	?
here. Start	Run on (no new paragraph)	⌐	squashed lines	Insert space between lines	✳─✳
here. Speaking	Indent	⌐	ready, set go!	Ellipsis	⌐○○○
			Removing an extra line	Remove line spacing or white space	←→

3.3.2. Typography

Typography is the art and technique of creating and composing types to communicate a message. Typography is also the study and classification of different typefaces.

3.3.2.1. Anatomy of type

Some of the terminology used is inherited from Gutenberg's movable type.

A **type or character** is the design of a certain letter. Although historically text layout was a job for the prepress technician, [3] computers have made it the designer's job to compose using desktop publishing software.

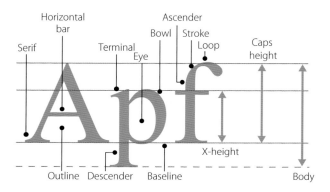

Anatomy of movable type

Anatomy of type and characters today

3. See 1.2.4. page 16

3.3.2.2. Characteristics of characters and paragraphs

Typesetters are responsible for **matters related to characters** such as:

- **Typeface:** the style or appearance of a complete group of characters, numerals and signs designed with shared characteristics.
- **Type family or series:** set of types based on the same font, with certain variations such as thickness, width, angle, etc
- **Body:** the height of the letters from the lowest point of the descenders to the highest point of the ascenders, measured in points.
- **Type spacing or width:** the space occupied by a character is called the set width. Its size is related to the body, but its width can vary depending on the shape of the letter (the letter 'I' does not need same width as the letter 'M').
- **Kerning:** the space between pairs of characters, which is adjusted when the typeface is designed.
- **Tracking:** the space between characters and between words.
- **Line spacing:** the space between lines, from baseline to baseline.

The points system used in continental Europe (and modified by Firmin Didot in 1785) defines the **point** as 0.0148 inches (0.03759 cm). The point is the base unit, whereas the cicero is the larger unit. There are 12 points in a cicero. **Cicero** is the name used in Spain, France and Germany; in Italy it is called a 'riga', and in the Netherlands an 'augstijnen' or 'aug'.

In the UK, the USA and other English-speaking countries, a system created in 1870s is used that defines the **point** as 0.0138 inches (0.03505 cm). In those countries, there are 12 points in a **pica**.

Example:

Typeface	Helvetica
Family or series	Bold
Body	10 points
Tracking	0 points
Line spacing	12 points

Bistiant re, voloratur? Pid quatectat verfero blaccus truptas quas ut unto quis sinveratur

Sample characters

Lorem ipsum is the placeholder text usually used in draft documents in graphic design before the actual text is available.

Typesetters are also responsible for **matters related to paragraphs** (groups of text, the first line of which is on a new line), such as:

- **Alignment and paragraph justification:** alignment of the start or end of the paragraph lines.
- **Indentation:** the insertion of several blank characters at the start of a line.
- **Initial letters:** letter at the beginning of a paragraph that is larger than the rest of the text.
- **Hyphenation:** separation of words between syllables at the end of a line of text.
- **Column justification:** ensuring the baselines of all the columns of text are aligned with each other.

Example:

Alignment and justification	Full justification, with the final line aligned to the left
Indentation	20-point first-line indent
Initial letters	Initial letter for one character occupying two lines
Hyphenation	Separation of syllables with no more than three consecutive hyphenated lines and without hyphenation of the final word of the paragraph
Column justification	Vertical alignment of columns

Lorem ipsum dolor sit amet, consectetuer adipiscing elit. Aenean commodo ligula eget dolor. Aenean massa. Cum sociis natoque penatibus et magnis dis parturient montes, nascetur ridiculus mus. Donec quam felis, ultricies nec, pellentesque eu, pretium quis, sem. Nulla consequat. Massa quis enim. Donec pede justo, fringilla vel.

Sample paragraph

In the character palette in InDesign, settings such as the font, body, family, tracking, kerning, position of the baseline, line spacing, distortion, angle and the language of the automatic spellchecker can be adjusted.

Legibility is the ease with which a text can be read. The readability of a text is the extent to which it is easy and pleasant to read.

In the paragraph palette in InDesign, settings such as the alignment and justification, paragraph and first-line indentation, initial letters, hyphenation and column justification can be adjusted.

It is also possible to save the settings as a character style or paragraph style that can be batch applied to large portions of text.

3.3.3. Digital fonts

Digital fonts describe the **glyphs** of each character. **Glyphs** are graphical representations of a character, a series of characters or part of a character. A character is a textual unit, whereas **a glyph is a graphical unit**. For a single font, a single character can be assigned more than one glyph, each of which is a variant of the character.

3.3.3.1. PostScript Type 1

PostScript is a page description language developed by Adobe in which types are described using Bézier curves, meaning a single set of types can be made larger or smaller through simple mathematical transformations. PostScript fonts are split into two files: one optimised for printing and one optimised for on-screen viewing. The fonts are different for each platform (Mac or PC) and are managed using a font manager.

3.3.3.2. TrueType

TrueType is a standard font format that also uses Bézier curves to make the fonts scalable. Initially developed by Apple in the late 1980s, this format was created to be a commercial competitor for Adobe's PostScript Type 1 format. The main strengths of TrueType fonts are: only one file is needed, they are cross-platform fonts, and, if the user wishes, they can be managed directly by the operating system. Despite these benefits, they have one major flaw: there are often problems with the rasterisation of fonts.

3.3.3.3. OpenType

The OpenType format was conceived by Microsoft and Adobe to succeed the TrueType and PostScript formats. The format provides cross-platform compatibility and a single working file, as well as more detailed description of the glyphs. Its support for Unicode also enables a single OpenType file to contain much more information (entire families and series,

variable glyphs that change according to their position in the word, etc.). OpenType fonts can be managed using the operating system or a font manager, whichever the user prefers.

3.3.3.4. Font management

Although TrueType and OpenType fonts can be managed directly from the operating system, that is, they can simply be installed to be used in any graphic design program, it is preferable to use a **font manager** (ATM, Suitcase, etc.) so the user can organise them into folders and more importantly activate and deactivate them quickly and easily according to whether he or she wants to use them in the current project.

It is important to highlight the subject of **font copyright**. Although many fonts are copyright-free, many others are not. It is therefore important to check the permissions and restrictions of the licences of proprietary fonts. Most fonts do not allow copying or distribution, so it is essential to export to a PDF or vectorise the font before sending the native file to the printer (even though this will make the text non-editable).

3.4. Images

An image is one of the basic elements of graphic design compositions. Images together with text placed within a page format form the graphic composition. Leaving aside the morphological and semantic aspects of graphic images, we will focus our attention on technical aspects that affect the printing of images.

For images to be incorporated into a design they must be digital. Either **analogue** images such as analogue photographs, printed material, slides and illustrations can be digitised using a scanner, or images already held in **digital files** such as digital photographs and digital bitmap or vector illustrations can be used.

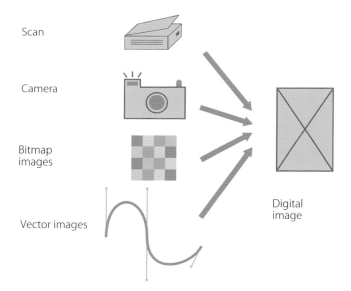

Scan

Camera

Bitmap images

Vector images

Digital image

3.4.1. Description of digital images

Digital images, which are encoded using binary code, can be divided into two major groups according to their format.

3.4.1.1. Vector images

Digital images stored using mathematical formulae that describe their geometry. This results in a series of independent graphic objects defined by coordinates and vectors that join those coordinates.

There are various ways of encoding images using vectors, the most common of which among vector graphics programs and file formats is that which is based on **Bezier curves**. Bezier objects are line segments connected by endpoints that create objects with straight lines and curves and with open or closed outlines.

Vectorisation is the process through which an **image described in a bitmap format is converted into a vector image.**

In 1960, Pierre Bézier conceived a method to describe curves mathematically. This method began to be used successfully by technical drawing software.

Endpoints are anchor points that define the curvature.

3.4.1.2. Bitmap images

Digital images stored using a two-dimensional matrix (width by height) of **pixels** . The image is divided up to form a grid of pixels, and the information is described pixel by pixel.

Each pixel position is thus assigned a value corresponding to its location and colour. The grid size (the number of squares) determines the quality of the image, which is called the **resolution**. The number of bits used for encoding the colour of each pixel determines the **colour depth, that is, the maximum number of colours the image can have**.

Rasterisation is the process through which an **image described in a vector graphics format is converted into a set of pixels.**

Bitmap image

Pixel is an abbreviated form of 'picture element'.

1 inch = 2.54 cm.

1INCH

4 ppi =
1,575 ppcm

1 cm

3.4.2. Resolution

Resolution is the **number of individual image elements (pixels) per unit of length** (**cm** or **inches**). It is expressed in **ppi** (pixels per inch) or **dpi** (dots per inch). The greater an image's resolution, the more space it takes up on a computer.

Sometimes an image's resolution is expressed by indicating the number of pixels on each axis of the image. An 800 x 600 pixel image, for instance, has 800 pixels on the horizontal axis and 600 on the vertical axis, giving it a total of 480,000 pixels (800 x 600 = 480,000).

The greater the number of pixels per inch, the smaller the pixel, enabling a more detailed image.

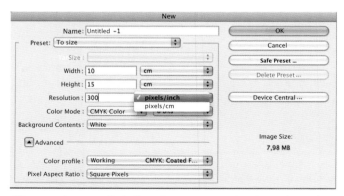

When opening a new file in Photoshop, it is essential to choose the resolution (in ppi or ppcm) and the image size.

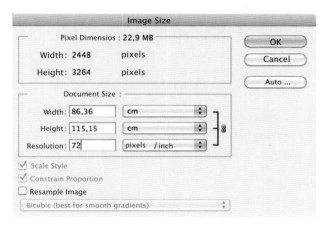

In the 'Image Size' option of the 'Image' menu, the user can check the resolution and change it if necessary.

3.4.2.1. Optimal resolution

The optimal resolution of a digital image is **the resolution it should have when printed to guarantee it prints correctly.** It depends on the screen ruling [4] that will be used, which in turn depends on the printing system and type of paper employed.

Working with a **below-optimal resolution** causes pixelation problems. Working with an **above-optimal resolution** results in unnecessarily large files.

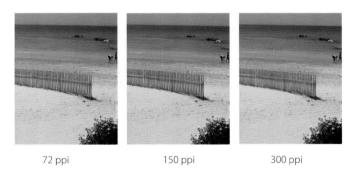

| 72 ppi | 150 ppi | 300 ppi |

Images printed with a screen ruling of 175 lpi

The following formula is used to calculate the optimal resolution for an image at its final reproduction size:

Screen ruling x 2 = Optimal resolution
 Example: 150 lpi x 2 = 300 ppi

4. See 3.6.1. page 100

For line art, monochrome or binary images the following formula is used:

Screen ruling x 4 = Optimal resolution (line art)
 Example: 150 lpi x 4= 600 ppi

Common optimal resolutions:
- Offset printing: 300 ppi (monochrome images: 600 ppi)
- Rotogravure printing: 300 ppi
- Flexographic printing: 150 to 300 ppi
- Screen printing: 100 to 200 ppi
- Large-format digital printing: 72 to 150 ppi
- Small-format digital printing: 200 to 300 ppi

Although it is useful to know and apply the formulae listed below, the most important thing is to consider all these factors so that somehow the images are obtained with a resolution that is as close as possible to the optimal resolution.

3.4.2.2. Reproduction ratio

When adjusting the resolution of an image, **the designer should take into account**, irrespective of the input device used, **whether the original image will be enlarged or reduced** in the final composition.

If an image will be enlarged to twice its original size, it requires twice its optimal resolution; if an image will be reduced to half its original size, it can be captured at half its optimal resolution. But not all images are enlarged or reduced to twice or half their size, so a formula is used to calculate the optimal capture resolution from the reproduction ratio:

AR = OR x RR (Analysis resolution = Optimal resolution x Reproduction ratio).
Example:

Reproduction ratio: the ratio between one of the sides of a reproduction and the same side in the original. The pixels will be larger.
RR = RS / OS (Reproduction ratio = Reproduction side / Original side)

When the reproduction ratio is 1, the image is reproduced at the same size. If it is greater than 1, it becomes larger. If it is less than 1, it becomes smaller.

If a 300 ppi image is required but the original image (a digital photograph) was taken at 600 ppi and has the following dimensions:

Original image:
- Long side: 3 cm.
- Short side: 2 cm.

Image in the layout:
- Long side: 6 cm.
- Short side: 4 cm.

The reproduction ratio will be 2 (RR = RI / OI = 6 / 3 = 2).
If the image has to be reproduced at 300 ppi, it must be taken at 600 ppi (Optimal resolution x RR = 300 x 2 = 600 ppi)
The reproduction percentage is the percentage by which the original image is enlarged or reduced to produce the final image. In other words, it is the reproduction ratio multiplied by 100.

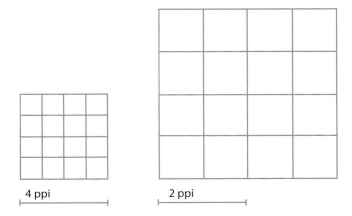

4 ppi

2 ppi

When a 4 ppi image is enlarged to twice its size, the resulting image has half the resolution: 2 ppi

An image should not be enlarged or reduced by more than 10% in the final layout.

3.4.2.3. Image scanning

A scanner is an **image digitiser**; an input device that **uses a beam of light to detect the patterns of lightness and darkness and/or colours** of a physical, analogue image and converts it into a digital image described by pixels.

Scanners detect the colours of the image by **emitting RGB (Red, Green, Blue) rays** 👁 [5] and converting them into pixels of each colour. The number of pixels that will describe the digital image is determined by the analysis resolution at which the analogue image is digitised.

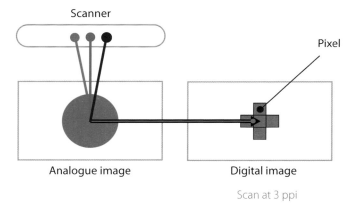

Scan at 3 ppi

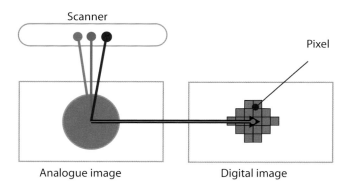

Scan at 5 ppi

5. See 3.5.4. page 98

Analysis resolution: the best resolution at which to scan an image. This resolution is calculated using the formula we have already seen:

AR = OR x RR

(Analysis resolution = Optimal resolution x Reproduction ratio)

Example:

An image has a reproduction ratio of 0.5 (i.e. it is reduced to half its size) and an optimal resolution of 300 ppi. The image must be scanned at 150 ppi so it has the right number of pixels.

(AR = OR x RR = 300 ppi x 0.5 = 150 ppi)

3.4.2.4. Resampling and interpolation

Resampling involves **altering the amount of image data** by changing the pixel dimensions or the image resolution. When **the resolution is reduced** (fewer pixels), **information is deleted** from the image. **If the resolution is increased** (more pixels), **new pixels are added.**

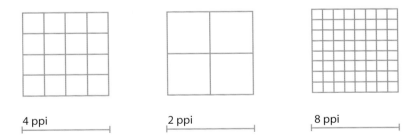

4 ppi 2 ppi 8 ppi

When a 4 ppi image is enlarged to twice its size, the resulting image has half the resolution: 2 ppi.

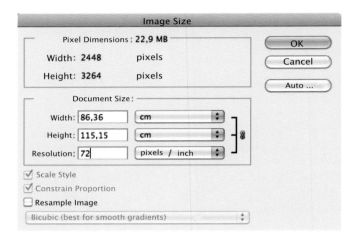

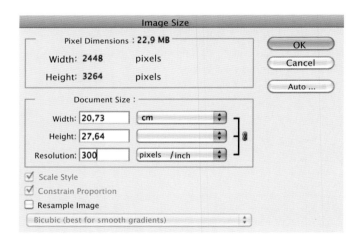

In the 'Image Size' option of the 'Image' menu in Photoshop, the image resolution can be changed with or without resampling. When an image resolution is changed without resampling, the dimensions change as the existing pixels have to be redistributed over each inch of the image..

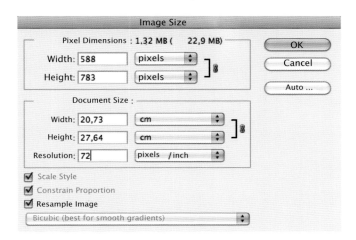

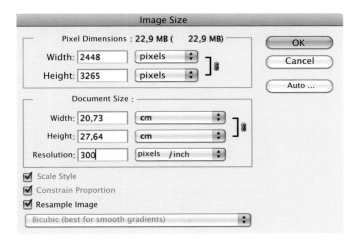

When an image resolution is changed with resampling, the printed image size remains the same, as new pixels are created or unneeded pixels are eliminated for each inch of the image.

One should remember that interpolation 'invents' pixels, which means it is not a good option if a high-quality image is desired. If the resolution is too low, it is best to find another image or produce it again.

Interpolation is the **method used to add pixels to an image** when the resolution is increased.

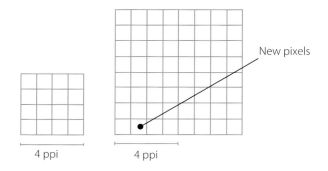

4 ppi 4 ppi

When a 400 ppi image is enlarged to twice its original size with resampling, the resulting image still has 400 pixels per inch, since 400 new pixels are created for each square inch of the image.

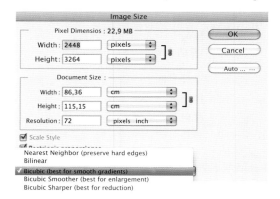

Photoshop resamples images using various interpolation methods that use different ways of assigning colour values to new pixels based on the colour values of existing pixels. The most common method used is bicubic interpolation.

3.4.3. Colour depth (bitmaps)

The number of colours a bitmap image can use is determined by the amount of information used to represent each pixel in the image. This information is known as the **pixel colour depth** or simply the **colour depth**.

How much colour information can be encoded depends on the **number of bits that describe each pixel in the image.** An image with a higher number of bits can have a greater range of colours and is larger in the sense that it **uses more storage memory** on the computer.

The bit is a digit of binary code and is the smallest piece of data possible. A bit can have one of two values: 0 or 1

Images can be classified as follows according to their colour depth:

Monochrome, binary or line art
Single-colour images. Each pixel can only be marked as full or empty (one bit per pixel)

Line art

Greyscale
Black-and-white images with tonal gradations of grey. The value of each pixel varies gradually among 256 intensities of grey, from black to white. (8 bits per pixel)

Greyscale

Duotone

Images that **use two colours**. The value of the pixel is based on the combination of the 256 tones of both of the two channels that compose the image. (8 bits per pixel x 2 channels = 16 bits per pixel)

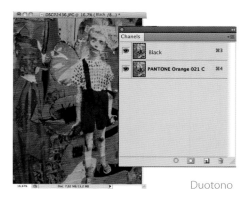

Duotono

RGB colour

Images that are described using **three channels.** The value of each pixel is based on a combination of the 256 tones of each of the **three channels** (R, G & B) that form the image (8 bits per pixel x 3 channels = 24 bits per pixel).

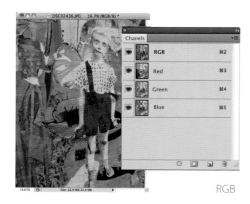

RGB

CMYK colour

The value of each pixel is based on a combination of the 256 tones of each of the **four channels (C, M, Y and K)** that form the image (8 bits per pixel x 4 channels = 32 bits per pixel).

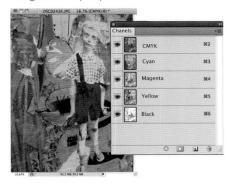

The colour mode can be changed, thus also changing the colour depth, in the 'Mode' option of the 'Image' menu.

Channels	Prof. Pixel	Tones	Image type
1	1 bit / pixel	$2^1 = 2$	Binary image
1	8 bits / pixel	$2^8 = 256$	Greyscale
2.	16 bits / pixel	$2^{16} = 65536$	Duotone
3	24 bits / pixel	$2^{24} = 16,777,216$	RGB colour
4	32 bits / pixel	$2^{32} = 4,294,967,296$	CMYK colour

The alpha channel is an additional channel that adds information regarding an image's transparency.

3.4.4. Digital image formats

Image formats can be classified by various parameters.

By how they are described in the file:
Vector graphics: described using Bézier curves. [6]
Bitmaps: described using pixels.
Metafiles: combine vector graphics, bitmaps and type.

By compatibility with other applications:
Native: used in only one application.
Compatible: can be used in more than one application.

By data compression:
Uncompressed: no compression used.
Compressed: some form of compression used to reduce the file size so it takes up less space on the computer.
- **Lossy:** compression results in lost information.
- **Lossless:** compression does not result in lost information.

3.4.4.1. The most common formats

Format	Type	Characteristics
TIFF 'Tagged Image File Format' (.tif)	Bitmap Compatible Uncompressed	The most common format for saving photograph images in different colour modes. Some vector data and transparency can be saved.
EPS 'Encapsulated PostScript' (.eps)	Metafile Compatible Uncompressed	Saves images as bitmaps, but also vector data such as clipping paths and multichannel colour separations.
PS 'PostScript' (.ps)	Metafile Compatible Uncompressed	Page description format that saves bitmap images, vector graphics, typography and printing instructions.

6. See 3.4.1. page 76

PDF 'Portable Document Format' (.pdf)	Metafile Compatible Uncompressed	Page description format that is more advanced than PostScript and saves bitmap images, vector graphics, typography and printing instructions.
JPEG 'Joint Photographic Experts Group' (.jpg)	Bitmap Compatible Compressed	Web format conceived for photograph images. Its compression scheme distinguishes between more important and less important information. The user can adjust the amount of data that will be lost.
GIF 'Graphics Interchange Format' (.gif)	Bitmap Compatible Compressed	Web format conceived for spot colour images. Stores a 256-colour palette or indexed colour, as well as transparency.
PNG 'Portable Network Graphics' (.png)	Bitmap Compatible Compressed	Web format conceived for photographs and spot colour images. Stores colour as indexed colour and RGB, as well as transparency. Also the native format of Fireworks.
Adobe Illustrator (.ai)	Vector graphics Native format Uncompressed	Native format of Illustrator.
Adobe InDesign (.indd)	Metafile Native format Uncompressed	Native format of InDesign.
Adobe Photoshop (.psd)	Bitmap Native format (compatible with Adobe applications) Uncompressed	Native format of Photoshop. Can save transparency.
ZIP, RAR, etc. (.zip, .rar)	Metafile Compatible Lossless compression	Format often used to group together and compress folders containing various files.

3.4.5. The size of the digital image file

The file size **is the space an image takes up on a computer. The size** of a digital image file depends on three factors:

- **Format:** the format and the level of compression determine the size of an image file. Vector graphics are normally smaller than bitmaps. JPEG images are also much smaller than TIFF and EPS images, for example.
- **Resolution:** the more pixels an image has, the larger the file.
- **Pixel colour depth:** the size of an image file also depends on the amount of data used to encode its colour. A file containing a CMYK image is four times the size of the same image in greyscale, since four colour channels are needed to describe it, rather than one.

3.4.6. Copyright of images

is a form of protection for authors of original works (including images) that is provided by the current legislation in most countries. Designers should check the copyright of an image before inserting it into a project or printing it.

Copyrighted images cannot be used without the author's permission.

Copyright vs copyleft

Copyright refers to the rights that an author can grant to third parties. The main rights are the right to reproduce, distribute and broadcast and the right to create derivative works. The term 'Copyright' or the © **symbol is conventionally used to indicate that all rights for a work are reserved.**

To find out whether an image with a Creative Commons license can be used or not, for instance, the rights granted to users by this type of licence should be checked (all rights, rights for non-commercial purposes, etc.).

Copyleft refers to a **form of licensing meant to guarantee the rights or freedoms of everyone as a 'user' of a work**, granting all people permission to reproduce or distribute it or create derivative works. The free culture movement and advocates of open content have developed **various forms of licensing to preserve authors' rights while also guaranteeing that some of those rights are granted to third parties as users.** One of the most famous types of licences is that created by the American non-profit corporation **Creative Commons.**

Public domain

The public domain refers to all **publicly owned property and rights** that are not private property.

Public domain images can always be used.

3.5. Colour theory

Colour is a rather **complex** subject that often leads to problems in the graphics industry, since **many aspects** affect colour, which is a **highly subjective area.** In the graphics industry, colour is worked on using **different colour models and many different devices** (the RGB monitors of the designer, clients and prepress technician; printers used for CMYK proofs; and final four-colour, six-colour or Pantone printing, etc.). More and more systems are being developed to measure and control colour, enabling those involved in the graphic design process to work more objectively. For this reason, it is important to understand certain concepts relating to colour theory.

Designer's monitor

Client's monitor

Client's printer

Prepress monitor

Plotter for proofs

Printing equipment

3.5.1. Perception of colour

Three variable factors affect people's **perception of colour**: the **object** being viewed, the **light** illuminating it and the **subject** observing it. The perception of colour of a given object inevitably varies when there is a change in the light or in the observer.

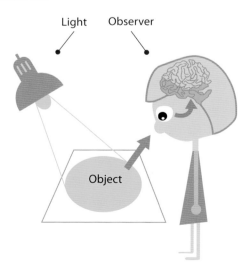

Light Observer

Object

Light

Light is energy of different wavelengths, amplitudes and directions that form the **electromagnetic spectrum**. The **visible spectrum** refers to the area of the electromagnetic spectrum **that the human eye can perceive.** This range of wavelengths (approximately 380-780 nanometres) is called **visible light**, or sometimes simply 'light'. There are no precise limits to the visible spectrum, since every human eye responds to wavelengths differently. The **colour temperature** of light also influences perception of the colour of objects. 👁 7

A nanometre is one millionth of a millimetre.

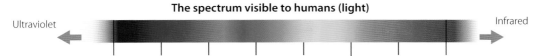

The spectrum visible to humans (light)

Ultraviolet | Infrared

The observer

The human eye receives visual stimuli in the **cones** and **rods** of the retina. These stimuli form an image that the **optic nerve sends immediately to the brain**, where it is processed **subjectively**.

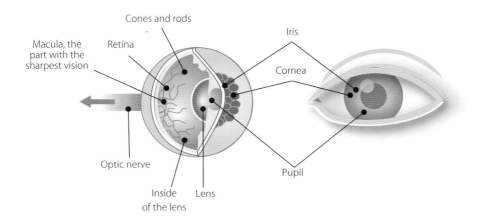

Cones and rods

Macula, the part with the sharpest vision

Retina

Iris

Cornea

Optic nerve

Inside of the lens

Lens

Pupil

Human eye

7. See 3.2.2. page 64

95

3.5.2. Colour measurement

To **measure the colour of an object**, the variables of the **observer and light should be constant**. The observer must become a calibrated measuring instrument (colorimeter, spectrophotometer, etc.) and the light should be a standard, neutral light (5,000K/D50). 👁 [8]

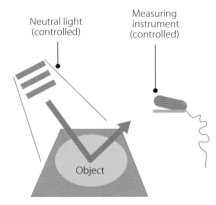

Neutral light (controlled)

Measuring instrument (controlled)

Object

The colour can be measured because the parameters of the illuminating light and the observer are fixed.

Colorimetry

Colorimetry is the **science that studies colour measurement** and develops methods for quantifying colour, that is, obtaining numerical values of colour.

3.5.2.1. Colour measurement instruments

Various types of colour measurement instruments exist, depending on the origin of the light being measured (light source or transparent/opaque object) and the type of data they produce.

Colorimeter

A colorimeter measures the tristimulus values resulting from the reflection or transmission of a certain surface. Colorimeters normally use the CIE chromaticity coordinates (XYZ, L* a* b*, RGB, etc.). There are two main types of colorimeters: those designed to measure light sources and those designed to measure materials.

8. See 3.2. page 64

Spectrophotometer

These are useful for measuring opaque or transparent surfaces, for which they produce a spectral curve. Spectrophotometry deals only with the visible region of the spectrum, so spectrophotometers are designed to take measurements between 380 and 780 nanometres.

Spectroradiometer

A device very similar to a spectrophotometer, but designed to measure the spectral composition of light sources.

3.5.3. Colour mixing

White light is formed by three primary colours of light: red, green and blue. This is known as **additive synthesis** since the **three colours of light are added** to each other to give **white light.**

Additive synthesis

Objects that do not emit light obtain their colour from the pigments they contain. There are three primary pigment colours: cyan, magenta and yellow. This is known as subtractive synthesis, since the sum of pigments **subtracts reflected light**. The sum of the three primary pigment colours results in the **colour black.**

Subtractive synthesis

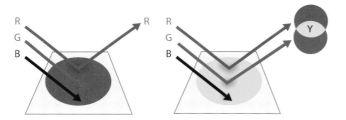

Depending on the pigment on an object's surface, it will **absorb or reflect different types of light**, enabling us to perceive one colour rather than another.

3.5.4. Colour models

Various models exist to describe colour in different ways. The most common models in the graphics industry are as follows:

3.5.4.1. RGB model (red, green, blue)

This is a colour model **based on additive synthesis** by which it is possible to represent a colour by **mixing** the **three primary colours of light: red, green and blue**. This model is used in devices such as TVs, monitors and projectors. The intensity of each component is measured on a scale of 0 to 255. The colour white is formed with all three primary colours at their maximum level (255, 255, 255).

RGB

3.5.4.2. CMYK model (cyan, magenta, yellow, black/key)

This is a colour model **based on subtractive synthesis** by which it is possible to represent a colour by **mixing** the **three primary pigment colours: cyan, magenta and yellow.** This model is used in colour printing. The intensity of each component is measured on a scale of 0 to 100. The colour black is formed with the three primary colours at their maximum level (100, 100, 100), but due to impurities in the pigments the result of this combination is a greyish brown; that is why a **fourth key colour** (black) is added, which helps resolve these deficiencies.

CMYK

3.5.4.3. HSV model (hue, saturation, value)

Also known as HSB (hue, saturation, brightness) or HLS (hue, lightness, saturation), the description of colour used in this model is based on **three perceptual aspects** that can be applied through visual colour assessments: the **tone or hue**, which responds to the dominant wavelength of a colour (red, blue, yellow, etc.); the **brightness** (value, brightness, luminance), which is the percentage of incident light reflected by a surface; and the **saturation**, which is the purity of the colour, so if a colour is very saturated, it is formed, in almost its entire intensity, by a dominant wavelength.

HSV

3.5.4.4. CIE models

The International Commission on Illumination (**CIE**) is the international authority on matters concerning light, illumination and colour, and **proposes several colour models** to describe colour.

CIE XYZ model (1931)

This model describes all the **colours visible to a standard observer** in a three-dimensional figure in which the tri-stimulus values X, Y and Z respectively represent the primary colours red, green and blue, the colours to which the three types of cone cells in the human eye can respond.

CIEXYZ model

CIE xyY model

The CIE xyY model was created to **represent the three-dimensional CIE XYZ model in two dimensions**. The CIE xyY model transforms the chromacity of the tristimulus values X, Y and Z into two dimensions (x, y) and presents them alongside a fixed luminance value (Y) with which it is possible to see a greater range of colours.

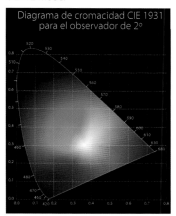

CIExyY model

CIELAB model (1976)

CIELAB is the broadest colour model, **describing all the colours that exist**. It is a three-dimensional representation of the three parameters **L, a, b** that represent, respectively, **the luminance, the position between magenta** and **green, and the position between yellow and blue**. The variations perceived between two colours are represented by equal distances in the diagram and expressed using the symbol ΔE (Delta E). CIELAB **describes how a colour looks rather than the** amount of colour needed for a device (monitor, printer, digital camera, etc.) to produce the colour. It is therefore considered a **device-independent colour model.**

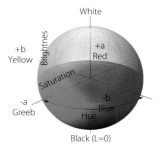

CIE Lab model

3.6. Colour or tone in printing

In addition to understanding the colour theory concepts presented in the previous section so a design can be printed with a variety of tones or in colour, designers must also ensure they do the following: screen the image, carry out colour separation, apply the appropriate colour and percentages and correctly convert the colour spaces of one device to those of another.

3.6.1. Screening

To reproduce, using any printing system, a greyscale or colour image in which we perceive continuous tonal and/or colour gradations, we need to break the image down into dots. Screening means breaking an image down into dots to make it possible to reproduce its various tonal values.

A continuous tone image is an analogue photograph in which the image is not broken down into points but is formed by a continuous range of tonal values.

Continuous tonal

Screening image

3.6.1.1. Conventional, periodic or amplitude modulation (AM) screening

This breaks the image down into **dots of various sizes** which, seen from a distance, give the impression of lighter or darker greys. The distance between the centres of the dots is always the same (they are **equidistant**).

Shape of the dot

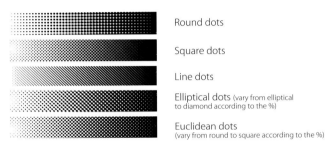

Round dots

Square dots

Line dots

Elliptical dots (vary from elliptical
to diamond according to the %)

Euclidean dots
(vary from round to square according to the %)

Screen ruling
This is the number of grid dots per unit of length (cm or inches). It is expressed in **lpcm** (lines per cm) or **lpi** (lines per inch). The screen ruling varies based on the printing system and the type of paper.

Common screen rulings:
Based on the type of paper:
- 65-85 lpi: newsprint
- 100-170 lpi: offset
- 175-200 lpi: coated

Based on the printing system:
- Offset: 65-300 lpi
- Rotogravure: 120-200 lpi
- Screen printing: 50-175 lpi
- Flexography: 90-175 lpi

Angle
For the colour separation screens to be visible, they must be placed at different angles. The pattern formed by the different overlapping angled screens is known as **printer's rosettes**. The **angles** the colour separations should be placed at **were established after careful study so as to avoid unwanted optical distortions** such as moiré patterns. [9]

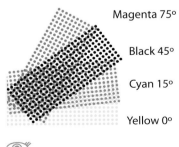

Magenta 75°

Black 45°

Cyan 15°

Yellow 0°

9. See 6.2.1. page. 206

Stochastic screening

3.6.1.2. Stochastic, or frequency modulation (FM) screening

This breaks the image down into **dots of the same size** which, when distributed **closer together or farther apart**, give the sensation of lighter or darker greys. The **distance** between the centres of the dots is **random**.

In stochastic screening **there is no screen ruling or angle.** Instead we refer to the **resolution**, which is usually the same as the device's maximum resolution, that is, the maximum number of dots a device can print per unit of length. A 2,400 dpi film recorder actually has this stochastic screening resolution, and the minimum dot pitch is determined by the maximum resolution of the output device.

3.6.1.3. Hybrid screening
This combines the characteristics of periodic and stochastic screening, using FM or periodic screening in areas with much light (0-10%) and AM or stochastic screening in shaded areas (80-90%).

3.6.2. Tonal reproduction
The differences between lighter and darker tones are expressed in **screening percentages** (%). These percentages describe the proportion of an image's surface area that is covered. A 50% screen ruling means as much of the surface is covered in ink as is blank. In tonal reproduction the designer must attend to the following:

3.6.2.1. Total ink limit
The **ink coverage** is the **sum of the various screening percentages for each separation.**

Example:
50% cyan + 100% magenta + 80% yellow + 20% black = 250% coverage

The **total ink limit** is the **maximum amount of ink** that **can be applied to a specific paper with a given printing system.** This limit is expressed in percentages. Printing with all four inks (C, M, Y and K) at maximum values (100%) yields a coverage of 400%. Applying that much ink to any medium causes problems with drying and ink setoff, since each type of paper can absorb only a certain amount of ink, so the total ink limits should not be exceeded.

Some of the most common total ink limits:
- Coated paper: 340%
- Offset paper: 320%
- Press paper: 240%

3.6.2.2. Dot gain

This is an **increase in grid dot size after printing**; it reflects a difference between the desired tone percentage and the percentage that is actually printed. This difference depends on the calibration of the raster image processor (RIP), the type of paper, the characteristics of the printing machine, etc. In so far as is possible, the designer should compensate for dot gain in the file and in the calibration of the RIP by making the dots smaller than they should be so that they become the desired size as a result of the dot gain.

3.6.2.3. Printable percentages

In the very dark areas, the grid dots begin to overlap, run together and blur. In **the very light areas,** the dots **can become invisible**. The value at which the grid dots run together is the **maximum printable percentage**. The value at which the dots disappear is the **minimum printable percentage.**
- Newsprint: 240%

3.6.3. Separations

To reproduce a colour image the colours must be separated. In other words, **several screened images are required that,**

when superimposed, **create an optical effect** in the human eye that **simulates tonal gradation with a wide range of colours**. To create full-colour images, normally four screened images are combined, one for each of the basic colours: cyan, magenta, yellow and black (CMYK or four-colour printing). But six-colour printing (six basic colours) also exists, as does spot colour in which the colours are applied directly.

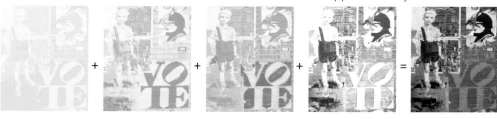

The superimposition of the CMYK colours of these four screened images creates a full-colour image.

3.6.4. Four-colour or CMYK printing

This is **printing using separations of the CMYK colour model.** [10] Superimposing different screening percentages from each of the separations of the colours cyan, magenta, yellow and black yields a **full-colour image.**

3.6.4.1. Black in CMYK

The way black is treated is often rather complex, since this colour can be formed using anything ranging from 100% black ink to 100% of all the CMYK inks. A large black background that uses only black ink will not have an intense black colour, while a black formed by 100% of all the inks will have setoff problems, since it will exceed the total ink limit. There are va-

10. See 3.5.4. page. 98

rious ways of achieving an intense black without having technical problems.

One way is to apply a 40% cyan wash to a 100% black.

Another way is to create a black with 50% cyan, 40% magenta, 30% yellow and 100% black.

The designer should consult the printer as to which composition of black is most appropriate for each substrate and printing system.

1. Black 100% (C:0, M:0, Y:0, K:100)
2. (C:40, M:0, Y:0, K:100)
3. (C:50, M:40, Y:30, K:100)

3.6.5. Six-colour printing

This is **colour printing achieved through separations into six colours:** modified versions of cyan, magenta and yellow, combined with black, green and orange (though there are other combinations). Superimposing various screening percentages from each of the separations yields a **full-colour image** that can reproduce a wider range of colours than four-colour printing. When working with six separations and with periodic screening, **the angles of the screens must be exactly right** because moiré problems can occur easily. That is why six-colour printing is **normally used with stochastic screening**, since it does not require an angle and therefore does not cause moiré patterns.

3.6.6. Spot colour, direct colour or flat ink

The colour **is created outside the printing machine** by mixing various basic inks. **The composition required for each colour is given in a colour guide** consisting of many small cards arranged by colour ranges on which samples of each colour have been printed. Each card specifies the percentages of ink required to produce the sample. This allows a wider colour range than four-colour printing, though spot colour cannot reproduce full-colour images, since the separations do not

Pantone Guide

- Pantone Guide on solid coated paper (C)
- Pantone Guide on solid matte paper (M)
- Pantone Guide on solid uncoated (offset) paper (U)
- Pantone Guide for CMYK colour (coated/matt/uncoated paper)

normally combine inks. Spot colour is normally used for vector graphics of logos, duotone images, etc.

The most common guide in the graphics industry is the **Pantone Guide**, which contains more than ten basic colours. The guide is available on various different substrates, since the appearance of a colour can vary greatly depending on the paper. There are Pantone guides for process colour (CMYK) and special inks such as metallic and phosphorescent inks.

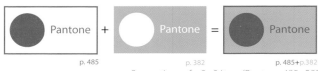

p. 485 p. 382 p. 485+p.382

Separations of a 2+0 item (Pantone 485+382)

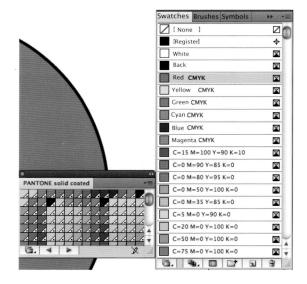

In the swatch palette in Illustrator and InDesign, colours can be defined using CMYK four-colour printing or be defined as spot colours using one of the many Pantone swatch guides

3.6.7. Colour management:

Colour management **aims to homogenise the representation of colour on all work devices and the conversions** from one device to another through International Color Consortium (ICC) profiles. These profiles attempt to reproduce for all devices the colour space that the machine and all other devices **at a print workshop are able to print.**

In customised colour management, the GCR (grey component replacement) and UCR (under colour removal) values, which vary the administration of black ink in colour conversions, are taken into account.

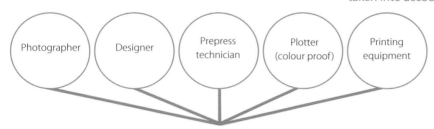

All use the same ICC profiles

Colour management

3.6.7.1. Colour standardisation

Colour standardisation is a **colour management method that aims to homogenise the representations and conversions of colour based on a standard** that covers the working tools of a typical print shop. The ISO 12647 standard regulates the technical specifications of printing in general and also refers to standardised colour management.

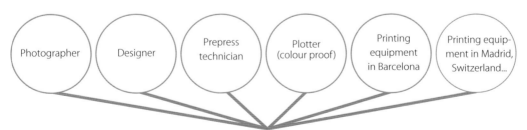

The same ICC standard profiles

Colour standardisation

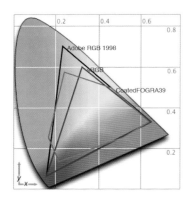

Adobe RGB, sRGB and Coated Fogra 39 (CMYK) standard colour spaces represented on the CIE xyY model

3.6.7.2. ICC profiles

An ICC profile is a **set of data that characterise a device or a colour space according to standards published by the International Color Consortium.** ICC profiles are accompanied by:

Gamut or colour space

Each ICC profile has a colour space that **describes the colours a device can reproduce.** This colour space, or gamut, is represented graphically using the CIE xyY model. 👁 11

Profile connection space (PCS)

The profile connection space serves to translate the values of a source profile to a reference space to obtain values for a destination profile. Colour management systems generally use the **CIELAB model as the connection space.**

Colour management module (CMM)

This is a software engine included with the graphic design application, operating system or driver used **containing the conversion tables** that link the values of the device's gamut colour to the value in the profile connection space (its LAB value). It also specifies how to convert the tones of the elements that are out of range when converting images from one space to another.

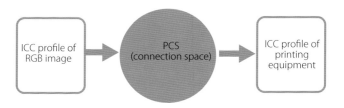

3.6.7.3. Profile conversions and assignments

Converting an image's profile involves changing the colour values while **maintaining the colour's appearance.**

11. See 3.5.4.4. page 99

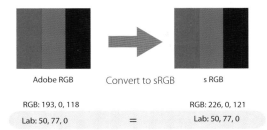

Adobe RGB	Convert to sRGB	s RGB
RGB: 193, 0, 118		RGB: 226, 0, 121
Lab: 50, 77, 0	=	Lab: 50, 77, 0

Assigning a profile to an image means **maintaining the colour values** and assigning the LAB values of the new profile.

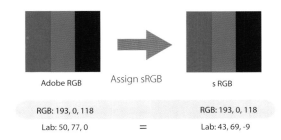

Adobe RGB	Assign sRGB	s RGB
RGB: 193, 0, 118		RGB: 193, 0, 118
Lab: 50, 77, 0	=	Lab: 43, 69, -9

An image without an embedded profile can only be assigned one profile. When converting from RGB to RGB, a profile can be assigned or the image can be converted. When converting from RGB to CMYK, converting the image is the only option. When converting from CMYK to CMYK, a profile can be assigned or the image can be converted.

Standard ICC profiles
These standard colour profiles are based on the behaviour of model devices that have been studied by organisations such as the CIE, the ECI, the ICC and Fogra.

Some of the standard profiles are:
- sRGB
- Adobe RGB (1998)
- Europe ISO Coated Fogra 27 (CMYK)
- Europe ISO Coated Fogra 39 (CMYK)

Photoshop, Illustrator and InDesign allow the user to choose the workspaces for the document. It is important to have activated dialogue boxes to warn of any profile discrepancies.

3.6.7.4. Colour management in the workflow

When working with a design program, designers must bear colour management in mind at all times. That is why they need to monitor the input and output profiles: what colour profiles the images and working documents have and what profile the print shop will use to undertake the task.

Early-binding colour management

An early-binding workflow means managing all work images and documents in CMYK and with the print output profile. Any images that do not have this profile must be converted or, if applicable, assigned so that they always use this profile. The resulting PDF has all the CMYK colours with the profile that will then be printed.

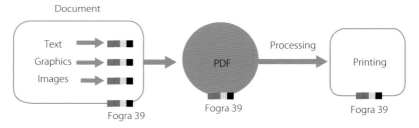

Early-binding colour management

Fogra 39 is a good standard ICC profile for offset printing.

Late-binding colour management

A late-binding workflow means managing all working images and documents with colour profiles such as RGB, CMYK and Lab colours. The resulting PDF contains information on colours described in various colour spaces. It is the printer who then converts the file to the- print profile. In a late-binding workflow, the designer must remember that colours can vary in appearance, especially those that are outside the CMYK range: some vibrant RGB colours, etc.

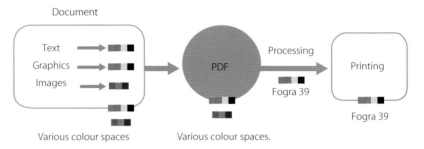

Late-binding colour management

3.7. Registration

In printing, **registering means making colours appear in the same place when two or more different separations are printed.**

Misregistration Perfect registration

Perfect registration in printing implies that two overlapping colours are printed in exactly the same place, while in print finishing it means the printed material is cut to exactly the right size. **The printing and finishing registration systems** are very exact but, since they are mechanical, **they do not achieve perfect registration;** There **will always be mild registration errors,** so certain factors must be taken into account during the prepress phase.

When an element is painted in 'Registration' colour in the swatch palettes of Illustrator and InDesign (this image is a screen capture from InDesign), the element is printed with all the colour separations that are contained in the file.

3.7.1. Overprint
Overprint

In overprinting, **the ink from the foreground object is superimposed on the ink on the next layer behind it.** This effect prevents registration problems but can lead to undesired colour shift in the objects.

If the foreground colour is very small and dark or black, overprinting is recommended.

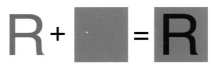

Overprint

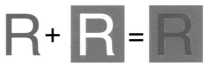

Knockout

Knockout

In a knockout, the **foreground object cuts out an empty, unprinted area in the object behind it.**

3.7.2. Trapping

Due to misregistrations caused by a knockout, if the foreground colour is light or large, blank spaces sometimes appear between two adjacent areas of colour. Trapping **forces the two colours to overlap slightly** (usually the lighter colour invades the darker colour).

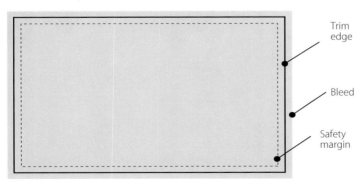

Expansion

Contraction

Both Illustrator and InDesign (this image is a screen capture from InDesign) have an 'Attributes' palette with which a line or fill can be overprinted. The user must activate the 'Overprint Preview' option in the 'View' menu to see this effect.

3.7.3. Bleeds and safety margins

Images that extend all the way to the edge of the paper in the finished product **are bleed images**. It is **important for them to extend 3 to 5 mm** beyond the edge of the page format to avoid problems with small inaccuracies in trimming. For the same reason, **it is advisable for the design to include an inner safety margin of 3 mm**, ensuring that the 3 mm closest to the edge will not include any graphic element that should not be trimmed away.

Trim edge

Bleed

Safety margin

Document with a bleed and safety margin

3.8. Revision and export to PDF

Exporting and **revising the document** that will be printed is one of the most important phases. During this phase the designer must **take into account all the characteristics we have looked at so far** to ensure that the files have been prepared properly to be printed correctly.

Producing a good PDF export is vital, since this is the **actual file exchanged between designers and printers.** Although sometimes designers may send the print shop the open, native file, designers increasingly export the files to a PDF themselves so they retain more control over their own work.

3.8.1. Preflight

Operation that consists of **checking that all the parameters that can affect optimal reproduction of a digital file** are correct and correcting them if they are not. These parameters can be checked **manually** or using **automated methods** on **native files** or **PDF files**.

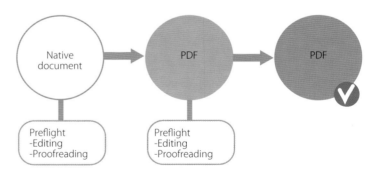

The ideal scenario would be to check the native document, export it to a PDF, and then check the PDF to ensure it has been created correctly.

InDesign includes a preflight panel with a customisable profile to check
various aspects of a document

Acrobat Pro includes preflight profiles as well as the possibility of adding
plug-ins to revise and edit PDFs (change colours, make minor edits to ima-
ges and text, etc.)

The most common preflight checks:
- Fonts are available and not corrupted
- Images are available
- Image resolution
- Document format
- Number of pages
- Colour mode and colour profile
- Colour separations
- Bleeds and safety margins
- Trapping and overprinting
- Total ink limit

- Lines too thin (less than 0.25 dots)
- Text too small (less than 4 pt, though this depends on the font)

3.8.2. PDF/X

PDF (Portable Document Format) **is a compact**, composite (combining vector images, bitmaps, typography, etc.), **cross-platform page description format** that can be generated from various applications. It has several specific standards for different uses.

PDF documents for printing can be created directly in applications using the 'Export to PDF' menu options. The applications allow the user to change the settings for PDF exports. PDFs can also be created by using Adobe Distiller to distill a PostScript file generated by the application in question (this option is being used less and less because more applications are including export menus).

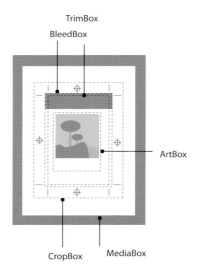

The marks and page limits are useful for imposition software.

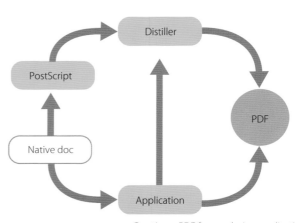

Creating a PDF from a design application

PDF/X (ISO 15930) is a **subset created for the reliable eXchange of files in the graphics industry.** The specifications it con-

tains are both restrictive (eliminating elements that are problematic to print) and additive (adding some elements required for printing). The most common actions it takes are:

Fonts

Checking that fonts are not corrupt and embedding the fonts used in the document.

Images

Checking all the links are available and embedding the images. Compressing the resolution using lossless compression.

Page description

Removing information such as links, notes, forms and scripts, and including information for the trim box, crop box, etc.

Colour

Depending on the PDF/X version, converting all the colours to CMYK and preserving the spot colour or allowing RGB or Lab colours 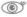 [12], according to the colour management required.

There are several versions of PDF/X, of which the most common are:

- **PDF/X 1a** (2003): Adobe PDF 1.4. Only supports CMYK and spot colour.
- **PDF/X 3** (2003): Adobe PDF 1.4. Supports CMYK colours, spot colour, RGB, Lab, etc.
- **PDF/X 4** (2008): Adobe PDF 1.4. Supports CMYK colours, spot colour, RGB, Lab, etc. Supports layers and live transparency.

Working with PDF/X improves file exchanges but does not ensure that the resulting PDF will be optimal for printing. PDF/X checks a series of parameters, but it cannot check every aspect relevant to the file's proper reproduction. It is therefore vital that the designer and prepress technician must know and check the variables used to prepare the document.

A PDF can be created using the 'Export to PDF' option in InDesign or the 'Save as PDF' option in Illustrator. These options are both in the 'File' menu. Various customised settings are available, or the 'PDF/X Standard' option can be selected. The screen captures seen above show the Compression, Marks and Bleeds and Output panels. The latter contains the colour management settings.

12. See 3.5.4. page 98

3.8.3. Certified PDFs

Certified PDFs **retain a record of the preflight process** in which a **preflight profile** is applied first. An **evaluation report** is generated with the result of the first check of the PDF, an **event log** is created (in case there are corrections to the PDF file), and finally a verification **certificate is produced.**

Certified PDF process: the PDF file prepared by the designer is checked; if everything is correct it passes certification; if there are any errors they are corrected – in the PDF itself if possible – but if not the PDF returned to the designer for correction before passing through the certification process again. Finally, a certificate is issued for the entire review process.

3.9. Imposition

A **leaf** is a sheet that has been printed and folded, although the word is also used to refer to a printed sheet of paper.

The **stripping or imposition** process consists of **placing and laying out the** pages so the **job can be printed** on a substrate of the size that will be inserted in the machine, in the correct order, with the necessary distances and control elements for printing and finishing, making maximum use of the format. The sheets **are arranged into the necessary order for printing.**

The word **stripping** is still used to refer to what in reality today is digital imposition.

The term 'stripping' comes from the **old manual stripping** methods using films, flats and light tables. [13] **Today**, the term used is **digital imposition**, which is done using **computer software** that orders the pages, working out the best layouts and adding the control elements. The software compiles the pages into a PDF, arranges them, and generates a PDF or PostScript file of the entire sheet.

The imposition process **also takes into account the number of inks, the number of printed sides and the substrate used** to make maximum use of the substrate and the plates. The details of the imposition are generally managed by the prepress technician, but very occasionally (if many products models are printed, such as different cards or postcards, or a bound publication has some sheets in four-colour printing and others in black, or different types of paper are used in different parts) the designer should know the details of the imposition by consulting an imposition dummy in order to maximise the use of the sheets according to the characteristics of the material being printed.

3.9.1. Print run

During imposition the print run is calculated **according to the number of products that can be repeated on a single sheet and how those products are laid out. The layout tends to be:**

13. See 1.2.8. page 20

Single-sided

The material is printed on one side, and not on the reverse.

Diagram of the printing of product A printed on one side only and requiring 2,000 copies. Since the product is repeated four times, there will be 250 print runs.

Double-sided

The front pages are all printed on one side of the sheet while the reverse pages are printed on the other side.

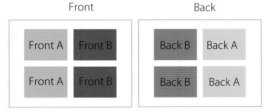

Imposition dummy of two different products – A and B – printed on both sides.

Work-and-turn and work-and-tumble

The front and reverse pages are printed on the same side of the sheet. The sheet is then turned horizontally (work-and-turn) or vertically (work-and-tumble) and the same imposition is printed again. The layout means that fronts and backs are lined up and printed on opposite sides of the sheet.

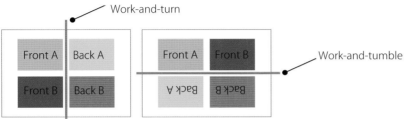

Imposition dummy of the same two products – A and B – printed with work-and-turn and work-and-tumble.

3.9.2. Plate impositions

Jobs that will only be **cut or folded. Unrelated elements** (cards, postcards, packs, labels, etc.) are distributed **across the substrate.** These are usually **repetitive jobs**, since the same product is usually repeated several times on the same sheet, or various product models are included and are printed on the same substrate with the same colours.

3.9.3. Bound impositions

Jobs that will be bound in which **one must be very aware of the print finishing**.

The sum of the page numbers of the two paired pages on a sheet is always equal to the number of pages on the sheet + 1 (for example, for an eight-page sheet, the sum of the paired pages (1+8, 2+7,···) is always 9).

Imposition means organising the pages of a publication onto each side of the printed sheet. The pages can be organised in a **regular** manner (the sheet is divided into an even number of page rows and columns) or an **irregular** manner (one side of the sheet is divided into an even number and the other side into an odd number).

Irregular sheets

12-page sheet

24-page sheet

Regular sheets

Front Back

| 1 | 2 |

| 3 | 4 |

4-page sheet

Front Back

| 4 | 1 | | 2 | 3 |
| 5 | 8 | | 7 | 6 |

8-page sheet

Front Back

| 5 | 12 | 9 | 8 | | 7 | 10 | 11 | 6 |
| 2 | 15 | 16 | 1 | | 4 | 15 | 14 | 3 |

16-page sheet

Front Back

4	13	16	1		2	15	14	3
29	20	17	32		31	18	19	30
28	21	24	25		26	23	22	27
5	12	9	8		7	10	11	6

32-page sheet

3.9.3.1. Stapling (no spine)

Impositions **for staple binding must allow for creep.** [14] **To compensate for creep, the pages are shingled**, that is, the pages are moved slightly towards the spine or towards the margins, as necessary.

14. See 5.3.5. page 186

3.9.3.2. Perfect binding and stitching (with a spine)

For **perfect-bound** and **stitched publications**, the **spine width**, which varies depending on the paper and the number of pages, must be checked.

Calculating a book's spine width

The following formula is used to calculate a book's spine width: [15]

[(weight x bulk) x (page count / 2)] / 1000 = spine width in mm

Table of generic volumes [16]

The distances between pages, the margins and even the joining in complex cases must be agreed upon with the print finisher to ensure that the print finishing is done correctly.

Paper type	Bulk
Gloss coating	0.8
Matt coating	0.90
Offset	1.25
Bulky offset	1.5

Example:
- 90 g offset paper.
- 500-page book

Weight x bulk = 90 x 1.25 = 112.5
Pages / 2 = 500 / 2 = 250
(Weight x bulk) x (page count / 2) = 112.5 x 250 = 28125
[(weight x bulk) x (page count / 2)] / 1000 = 28,125 / 1000 = **28.125 mm spine width**

3.9.4. Control elements

During imposition, **control elements** are also added, which **allow for quality control to be carried out and measurements to be taken during printing** and also **help with print finishing.** The most common control elements are as follows:

- **Crop marks:** these indicate where the sheet has to be cut.
- **Fold marks:** these indicate where the sheet has to be folded.
- **Collating marks:** these show the order of the bound pages

Collating marks

15. See 5.5. page 192
16. See 4.2.1.4. page 141

with the mark in the spine of each page so that the pages are collated in the correct order. [17]

- **Registration marks:** these marks are printed with each colour separation used in the job; if they do not line up to form a single image after printing, it indicates misregistrations in the printing process.
- **Print control strip:** this strip contains colour patches that serve to measure and check the colour throughout the print run. [18]
- **Colour separations:** these indicate the number of inks that must be printed and the colour to be used for each image carrier.
- **Job information:** this contains the Work Order number, client name, sheet, side and other information for the job.

Registration marks of a correctly registered document and of a poorly registered document

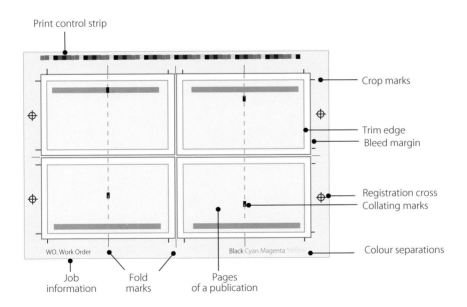

Print control strip

Crop marks

Trim edge
Bleed margin

Registration cross
Collating marks

Colour separations

WO. Work Order
Black Cyan Magenta Yellow

Job information

Fold marks

Pages of a publication

Imposition of a job with control marks

17. See 5.5.1.2. page 193
18. See 6.2. page 206

3.10. Proofs

Proofs are **print simulations** created **to check various aspects of the subsequent printing.**

There are different types of proofs:

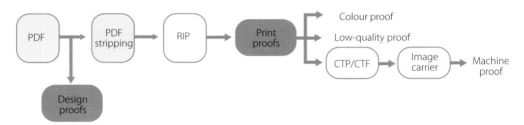

For print proofs, the **PDF created** following the stripping should be in its final form and should be processed with the same RIP as is used to rasterise the image for printing. This makes it possible to detect not only **colour shifts or errors in the stripping** but also **possible technical failures in the rasterisation.**

3.10.1. Design proofs

Design proofs include all **the samples the designer sends to the client** to the client to check the text and composition. These samples can be **digital files** viewed onscreen or **proofs printed** on a home printer (inkjet or laser). The colour perceived on these proofs **cannot be considered reliable, since it is not the same as the colour of the final print.**

3.10.2. Print proofs

3.10.2.1 Colour proofs

The mass use of plotters for colour proofs has sent the old types of proofs with films, such as blueline proofs and analogue Cromalin proofs, into oblivion.

These print proofs are mainly to **show the printed colour.** Most colour proofs are performed on **special paper** with a calibrated **plotter** [19] using the **ICC profile** [20] that corresponds to the **printing equipment on which the work will be printed or a standard ICC profile**, taking into account the paper on which the job will be printed to simulate its dot gain and base white. **The colour proof is a very faithful representation** of how the printing equipment will reproduce the **design colours.** Because the plotters used for proofs have CMYK cartridges (though with varying intensity), they may be limited in representing some Pantone spot colours. Similarly, when simulating black-and-white photographs, they may deviate

19. See 4.4.6. page 168
20. See 3.6.7.2. page 108

from the true colour because they use all the inks to print the photographs.

The **contract proof** is a **colour proof produced according to a standard** agreed upon. This proof includes a **standard print control strip** with colour patches that can be read using a spectrophotometer to objectively check whether the proof complies with the standard and falls within the tolerances it establishes. The international standard associated with ISO 12647 is the Fogra standard, with its Ugra-Fogra print control strip. One should note that colour proofs make the process more expensive and slightly slower.

3.10.2.2 Low-quality proofs

Low-quality proofs are printed to **check** that the **RIP rasterisation** was done correctly and ensure that all the design elements print well and that the **stripping** is correct. They are often also used so the print technician knows what the work will look like before printing it. These proofs are normally printed using a **plotter and low-quality paper** and a lower ink consumption than for colour proofs. For this reason, **under no circumstances can they be used as colour proofs.**

3.10.2.3 Machine proofs

For these print proofs, **the job is prepared as if it were going to be printed**. In other words, the image carriers are made and a **print run is initiated to print a few copies of the work.** Either special presses designed specifically for making proofs or the printing equipment itself can be used. Machine proofs **tend to be made for special jobs in which colour proofs cannot be made** and the print technician must check that the results are as expected as soon as the work comes out of the printer. These proofs are **particularly expensive**: there is the initial fixed cost (making the plates, setting up the machine, spoilage and cleaning the machine) of the printing system used to print the work. [21]

21. See 4.4. page 156

3.11. Making the printing form

Once the appropriate proofs have been made, **the imposition is sent to the RIP** (raster image processor), which **converts the page description data** (PDF or PostScript) **into raster bitmaps** so they can be reproduced via film, a plate, or printed directly on the substrate in the case of digital printing. 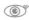 22

Once the image has been rasterised by the RIP, it is **transferred to a film** (computer to film, CTF) **or to a plate** (computer to plate, CTP).

CTF (computer to film)
Today, **CTF** is used practically only for **obtaining overlays for screen printing.**
When preparing a screen for screen printing, the film for the different colour separations is placed on the screen. Next, the film is placed against the screen, whose mesh has been coated with an emulsion, and they are exposed in the plate burner. ☞ 23 The areas exposed to the light harden, while the areas covered by the design on the film remain latent. Water is then used to remove the unexposed emulsion, making the areas containing the design permeable.

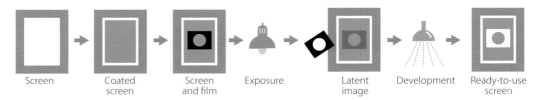

| Screen | Coated screen | Screen and film | Exposure | Latent image | Development | Ready-to-use screen |

Using CTF to make a screen for screen printing

CTP (computer to plate)
A **CTP** platesetter is used to obtain the **image carrier for each of the separations of three printing systems: offset** (plate), **rotogravure** (gravure cylinder) and **flexography** (plate). ☞ 24

22. See 4.4.5. page 167, 4.4.6. page 168
23. See 4.4.2. page 161
24. See 4.4.1. page 158

Taking offset printing as an example, the plates, coated with emulsion in the factory, are attached to the internal or external drum of the platesetter. Flatbed platesetters also exist for large plates. A laser (thermal or violet diode) images the plates, burning the non-printing areas. The image remains latent until the chemicals of the processor reveal it by removing the parts that do not contain the image. Today, plates exist that do not need chemicals to be developed. The latest technology includes CTP platesetters incorporated into the printing equipment, capable of painting plates supplied in rolls that do not need developing either.

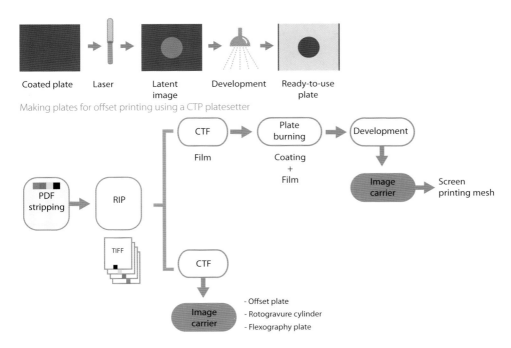

| Coated plate | Laser | Latent image | Development | Ready-to-use plate |

Making plates for offset printing using a CTP platesetter

The PDF created following the stripping is transferred to the RIP, which produces the colour separations. The data can be transferred to a film (CTF) or plate (CTP), according to the requirements. In CTF (used for screen printing), the films are made and must be exposed onto isolated on the screen so it can be developed and the image carrier can be made ready to be placed in the machine. In CTP, the images are transferred directly onto the plates (offset, rotogravure or screen printing). Once the image carriers have been developed, they are ready to be used for printing.

3.12. Summary diagram 3: The prepress process

Prepress process

Text

- Text corrections
- Well processed non-corrupt typess
- Appropriate digital font formats:

 ⊢ PostScript
 ⊢ TrueType
 ⊢ OpenType

- Font copyright

Images

- Analogue
 ↓ Scan
- Digital

- Bitmap
 Optimal
 resolution (300 ppi)

- Vector graphics

- Pixel colour depth
 ⊢ Greyscale
 ⊢ Duotone
 ⊢ RGB Colour conversions with
 ⊢ CMYK standard ICC profiles
- Formats
 ⊢ TiFF
 ⊢ EPS
 ⊢ PDF

Documents

Applications

- Image editing
- Vector graphics
- Desktop publishing

- Tone %
 ⊢ Screen ruling
 ⊢ Printable %
 ⊢ Total ink limits

- Registration
 ⊢ Overprint
 ⊢ Trapping
 ⊢ Margins and bleed

- Colour
 ⊢ CMYK (four-colour printing)
 ⊢ Six-colour printingplates)
 ⊢ Colour inks
 (Pantone)

- Colour conversions

Design proofs

The colour is not reliable.

PDF/X and preflight

PDF/X

A page description format for the exchange of files in the graphics industry..

Preflight

Checking and correcting

- Images and resolution
- Fonts
- Colour, separations and total ink limits
- Document and page format
- Bleeds and safe margins
- Overprint and trapping
- Thin lines and very small elements

Certified PDF/X

Including a verification report

Imposition and coverage of the image carrier

Imposition

- **Placing the pages on the sheet. Taking into account whether it is a:**
 - Plate imposition
 - Bound imposition
- **Adding control elements**

Image rasterisation

From PDF to bitmap

Colour proofs/ CTF/CTP
Low-quality
proof

Image carrier

Printing

- Offset
- Rotogravure
- Flexography
- Screen printing

Digital printing

4. PRINTING SYSTEMS AND MEDIA

4.1. Printing

If we understand **printing to mean affixing an image;** , then studying printing systems means **studying the various ways of affixing images**, of depositing **ink on a substrate** so the image adheres to it and becomes visible.

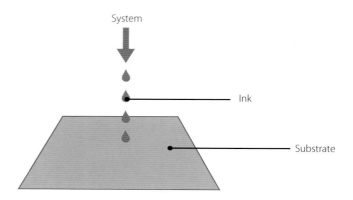

Printing: depositing ink on a substrate.

Every **printing system has** its own formal characteristics, its own inks and **its own appropriate substrates.;** Knowing the possibilities and limitations of each printing system allows the designer not only to successfully avoid their disadvantages, but also to take advantage of each process's technical specifics as significant creative advantages. We shall now look at the substrates, types of inks, systems and techniques that exist to make this possible.

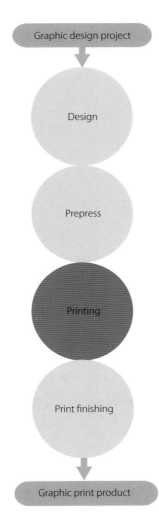

4.2. Substrates

The substrates **receive the ink applied to them by each printing system**, and must have the appropriate properties to make it possible to fix the colour. The choice of a particular substrate restricts the printing to specific techniques and inks, since not all media can be printed on in the same way. To decide which substrate to use, designers must consider various factors and are advised to ask the printer whether the design is viable, especially if they want to use an unusual substrate. But **what criteria should the designer use to choose the substrate?**

Function of the final graphic design product
When choosing from among the wide variety of possible media (paper, plastic, cloth, metal, etc.), the use of the final product is clearly the main aspect one must consider.

Visual or tactile characteristics
Another element to consider is the aesthetics of the design and the visual and tactile sensation of the substrate. Each communicative object the designer wishes to transmit (sell, inform, generate awareness, etc.) could require a different substrate.

Printing systems and inks
The substrate determines the type of ink and the printing technique that will be used. A wide variety of media exist, and not all of these can be printed on using all inks and all printing systems.

Quality of the printed image
A good reproduction of the images depends on the chosen substrate. If precise images are vital for a graphic design product, the media must be chosen accordingly.

Durability and strength
The quality, weight and thickness of the substrate is chosen according to how long the printed material should last and how sturdy it should be.

Finish and print finishing

Some media do not allow certain types of finishes, and not all media can be folded, cut, glued or bound well. The finishing or finish chosen also limits the choice of substrate.

Economic criteria

The choice of substrate and its characteristics can strongly influence the cost of the work. Therefore one substrate may be chosen over another based on the budget for the project.

The most common substrate is paper, so that is the substrate we shall look at in most detail in this chapter. But paper is not the only printable surface: **there is a wide variety of other substrates**; , and designers should know the characteristics of those media, which are being used more and more often.

4.2.1. Paper

4.2.1.1 A little history

Plant fibres were first used for writing in Egypt in around 3000 BC. The Egyptians made **papyrus** paper from the 'Cyperus paperus' plants they cultivated on the banks of the Nile. They would separate the outer rind from the stem and place thin, perpendicular layers on a damp surface. Next, they would press the strips and hammer the layers together to form a sheet. Once the sheet had dried, they would polish it with a smoothed stone. The use of papyrus began in ancient Egypt, but spread to other places, including Greece, where they changed its name to 'biblio' (which is the origin of the word 'Bible').

Nevertheless, **paper was born in China**. At the start of the **second century BC, Han Xin**, trying to find a fabric to make cheap outerwear, crushed silkworm cocoons, mixed them with water

Parchment was another substrate used for writing. Starting in the **third century BC**. It was made not from intertwining plant fibres such as papyrus and paper, but from animal hide. The skin had its hair removed and was then soaked and stretched to create fine sheets on which to write.

In the **tenth century**, the **Maya** and later the **Aztecs of Mexico** also produced a raw material to write on from the bark of fig trees and other plants.

and passed them through a mesh; the result was a fabric that could also be written on. Between the **second and third century AD**, **Cai Lun**, an official of the emperor, first described the manufacturing process of this fabric. Reviving the invention of Han Xin, and adding agar-agar to the mix, the adherence of the fibres was improved, **and so paper was born**. Later, silk was replaced by rags, and the next step was to replace the rags by pieces of bark from mulberry trees and other trees. The process involved pounding bark with water and passing it through a sieve to obtain a fibre mat that was left to dry in the sun before being polished with a stone.

Knowledge of paper began to spread in the eighth century, first to Uzbekistan, then to **Egypt** (where it replaced papyrus) and **northern Africa**, before **spreading** to **Europe via Spain** in the eleventh century. The use of paper gradually spread across the length and breadth of Europe, **reaching Russia** in the sixteenth century **and America** in the seventeenth century.

The advent of Gutenberg's ¹ printing press led to an increase in paper consumption, and **paper manufacturing began to undergo a series of improvements**, including the following.

- In 1670 and 1680, the Hollander beater was invented to beat old clothing.
- In 1789, the Frenchman Nicolas Louis Robert invented a machine to make paper with a continuous wire belt.
- In 1804, the Fourdrinier brothers made the first flat papermaking machine (the system on which today's machines are based).
- The steam engine and industrialisation were incorporated into the papermaking process, improving the beating of the pulp, the production of the stock, the drying process, etc.

4.2.1.2. Papermaking
In the papermaking process, **the pulp** (plant fibres from various sources) is **shredded, mixed with water** and **cleaned of impurities** in the **refiner**.

1.See 1.2.4. page 16

Then **fillers, pigments and additives are applied** in order to confer certain properties (porosity, strength, colour, etc.), as well as **binding agents** that help hold together the fibres that form the **paper stock**.

The **stock travels from the headbox onto a conveyor belt** to form a thin, wide sheet that is then **drained** as it is pressed between a wire mesh and rollers. At the same time, **transversal vibrations cause the fibres to intertwine**.

The wide sheets of paper are transported by pieces of cloth with **rollers that draw off** part of the **water**, leaving an even surface. Several presses with **absorbent felt cloth remove water** as they push against the paper with (steam-heated) drying drums.

The paper then moves through the **calender**, which is formed by a series of (hot or cold) rollers that apply pressure to achieve various levels of smoothness, gloss and compactness.

Finally, the paper is **collected onto large reels** to later make smaller rolls of paper or for cutting into individual sheets to be packaged.

Outside the paper machine, various procedures can be carried out **to achieve different finishes**. The most common is **coating**, which involves applying a coating compound

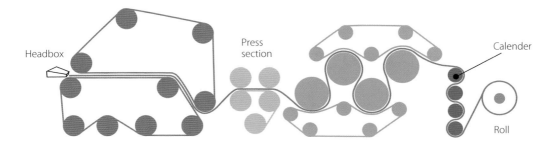

Papermaking diagram

70

100

100 x 70 (horizontal format)

100

70

100 x 70 (vertical format)

(clay with additives) and recalendering the paper. The pressure and friction applied during calendering determine how glossy the paper will be (sometimes the coating compound can be applied using the same machine that makes the paper). In this phase, **various operations can be undertaken** to create **adhesive, metallic or plastic** paper, etc.

4.2.1.3. Format

The format of a sheet of paper, a document or another rectangular substrate is **expressed by indicating its width and height respectively. Although the expression of the format makes it clear whether the layout is horizontal or vertical (landscape or portrait orientation) since the width always comes first, it is advisable to specify which of the two orientations is used.**

The **international standard ISO 216** (based on the German standard DIN 476) regulates paper formats. **In the A series, the reference is A0** (841 x 1190 mm), with a surface area of 1 square metre. This standard, accepted in almost the entire world, may vary slightly in some countries (e.g., the United States, Canada, Japan and Europe).

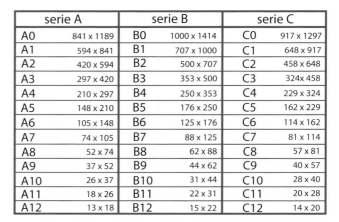

serie A		serie B		serie C	
A0	841 x 1189	B0	1000 x 1414	C0	917 x 1297
A1	594 x 841	B1	707 x 1000	C1	648 x 917
A2	420 x 594	B2	500 x 707	C2	458 x 648
A3	297 x 420	B3	353 x 500	C3	324x 458
A4	210 x 297	B4	250 x 353	C4	229 x 324
A5	148 x 210	B5	176 x 250	C5	162 x 229
A6	105 x 148	B6	125 x 176	C6	114 x 162
A7	74 x 105	B7	88 x 125	C7	81 x 114
A8	52 x 74	B8	62 x 88	C8	57 x 81
A9	37 x 52	B9	44 x 62	C9	40 x 57
A10	26 x 37	B10	31 x 44	C10	28 x 40
A11	18 x 26	B11	22 x 31	C11	20 x 28
A12	13 x 18	B12	15 x 22	C12	14 x 20

Besides the ISO/DIN standard, **there are other widely used for-mats** designed **so that the papers match the requirements of the printing equipment**. The most common European sizes are:

- 32 x 45 cm
- 43 x 61 cm
- 45 x 64 cm
- 52 x 70 cm
- 56 x 88 cm
- 63 x 88 cm
- 65 x 90 cm
- 70 x 100 cm
- 90 x 130 cm
- 100 x 140 cm
- 120 x 160 cm

Papermaking companies sell the same type of paper in vari-ous sizes. Besides the reference to the type of paper and the weight, the packaging states the following:
- **The format**: the second dimension indicates the direction of the grain.
- **The number** of sheets of paper: expressed **in reams** (1 ream= 500 sheets)

On a 100 x 70 sheet of paper, the grain runs in the direction of the 100 cm side.

4.2.1.4. Characteristics of paper

Paper has many characteristics: optical, physical and chemical properties determine its optimal printing and print finishing. Some of these characteristics are as follows:

Colour and whiteness

These are subjective characteristics that depend not only on the physical characteristics of the paper, but also on the light illuminating it and the observer perceiving it. **The colour** re-

fers to the shade of a particular type of paper. White paper is said to have greater **whiteness** when it has a slightly bluish look, rather than a yellowish look.

Opacity

Opacity refers to the paper's light absorption capacity and its ability to prevent the passage of light. Greater capacity means lower transparency. A paper's opacity is a result of its weight, the type of fibres with which it was made, the fillers and pigments added, the refining, and the pressing used.

High gloss coated paper results in high brightness, gloss and smoothness.

Brightness and gloss

These are related to reflected light. The more light a surface can reflect, the greater its brightness. If the paper reflects the light at the same angle at which it was shone on the surface, it is said to have greater brightness and smoothness.

Smoothness

This refers to the extent to which the paper resembles a completely flat surface. Smooth paper provides sharper images than rough or textured paper.

Weight

This is the weight in grams of a square metre of paper (g/m2). When we talk about 100 g paper, it means that a 1 square metre piece of this paper (an A0 sheet) weighs 100 g.

Porosity

A micron is one millionth of a metre.

The volume of air in the paper as a proportion of its total volume. The absorption, hardness and compressibility of the paper are directly related to its porosity. Paper is considered to have a high porosity when the pores have a diameter of 40-50 microns, and a low porosity when they have a diameter of less than 1 micron.

Thickness or caliper

This refers to the distance between one side of the paper and the other. It is measured in microns. A paper's thickness can be increased without necessarily increasing its weight; two sheets

of paper can have the same weight but a different thickness if they were made with different densities and compactness.

Bulk

The bulk is the relationship between a paper's weight and its thickness. It is important, since it is used to calculate a book's spine width. ² The greater a paper's bulk, the worse its printability.
- Bulk (cm3/g) = Thickness (microns) / Weight (g/m2)

Direction of the grain

When paper is made, the grain runs parallel to the conveyor on the machine on which it was manufactured. The paper's grain affects the behaviour of the printing equipment, due to the distortion of the paper's structure, and the subsequent finishing of the printed item.³

Direction of the grain

Other properties

Paper has other properties that can determine its printability and the quality of subsequent print finishing. These properties include acidity or alkalinity; humidity; resistance to tension, tearing, water, heat or abrasion; rigidity or permeability, etc.

4.2.1.5. Types of paper

Based on the composition of the fibres in the stock, we can distinguish between different types of paper made with different **kinds of pulp:**

Mechanical pulp

Cellulose fibres are extracted from the wood through mechanical processes. These fibres contain more impurities. They are generally used for products intended for short-term use: newspapers, facial tissues, napkins, etc.

Chemical pulp

Cellulose fibres are extracted from the wood through chemical processes, which yield purer fibres. Chemical pulp is gen-

2. See 3.9.3.2. page 124
3. See 5.3. page 182

erally used for products meant to last a long time: books, commercial printing, etc.

Rag pulp

The primary materials used in its manufacture are cotton and linen. Rag paper has very long, strong fibres. Rag pulp is generally used for high-quality paper, drawing paper or banknotes.

Recycled pulp

Recycled pulp contains fibres from used paper or paper waste, and is used to make recycled paper. Recycled paper is generally used for a variety of products: commercial printing, newspapers, magazines, etc.

Paper can be classified according to **whether it has been coated.** Coated and uncoated paper can both be made using mechanical, chemical, rag or recycled pulp:

Offset or uncoated paper

Offset paper just goes through the calendering phase without being coated afterwards. It is more porous than coated paper.

Coated paper

Coated paper goes through the coating phase, either in the papermaking machine or outside the machine. Depending on the degree of calendering that is then applied, it can be: matt, gloss or high gloss. The quality of the paper is affected by the composition of the pulp, the type of coating and the number of layers applied.

Paper can also be classified according to its **finish and appearance**:

Art paper

Art paper is a coated chemical-pulp paper. It is the highest quality coated paper, and generally has three layers of coating (one coat applied by the papermaking machine and two coats applied afterwards). Art paper is frequently used in high-quality books containing full-colour images.

Recycled fibres were not used in the papermaking industry until the 1960s.

Self-adhesive paper

Paper that has been coated with a very thin layer of glue on one side. Self-adhesive paper is used for stamps, labels, Post-it notes, etc.

Carbonless copy paper

Chemical pulp paper that has been coated on one or two sides. The paper is coated with microcapsules that break under the pressure of a ballpoint pen or typewriter, releasing a clear ink solution that reacts with the reactive surface of the paper below, becoming visible. It is frequently used for invoice books, receipt books, etc.

Textured paper

Normally uncoated chemical-pulp paper that shows marks from the rollers used in its manufacture (**laid** paper), some other texture applied with a mesh before the paper is dried, or a watermark produced by creating relief.

Paper with particles

Coated or uncoated paper, from any type of pulp, containing metallic powders, pieces of pigment, plants, etc. It is used in creative items.

Kraft paper

Very strong paper made from kraft pulp. It is used in particular for packaging.

Coloured paper

Coated or uncoated paper, regardless of the type of pulp used, that is dyed when manufactured to give it a colour other than white. It is used in creative items.

Newsprint

Uncoated mechanical-pulp paper. Newsprint is highly absorbent and turns yellow when it is exposed to light for a long time. It is mainly used for newspapers and magazines.

Tracing paper
Translucent paper treated with sulphuric acid. It is particularly impermeable to greases, oils and moisture.

High-bulk paper
Coated or uncoated chemical- or mechanical-pulp paper that is not very compact and has gone through very little or no calendering. High-bulk paper is thicker than most papers with the same weight and has quite a high opacity. It is normally used for reading books.

Card stock
Paper with a weight above 170 or 200 g is considered card stock. Paperboard is a type of thick paper very similar to card stock, commonly used for postcards. It often is coated on only one side.

Cardboard
Very rigid paper with a weight above 250-300 g made with low-quality materials.

4.2.2. Non-paper media
Although paper is the most widely used substrate, it is possible to print on other media using some of the printing systems described below.

4.2.2.1. Plastic
A **material resulting from a chemical process** called polymerization. Although **natural plastics** (shellac, latex, waxes, resins, etc.) and **artificial plastics** (derivatives of natural raw materials such as cellulose), the most common plastics used today are **synthetic** plastics (petroleum derivatives).

The first synthetic plastic was Bakelite, which was developed by Leo Baekeland in 1907.

There are **many times of plastics** (cellophane, polyester, polyethylene, polypropylene, polyvinyl, polyamide, polymethyl methacrylate, polystyrene, polycarbonate, etc.), the manufacturing processes of which give them **distinct properties**, such as greater or less durability, tension, static electricity, flexibility or rigidity. **Both flexible and rigid**, plastics are used instead of

Printing on plastic

paper if a stronger substrate is required and **instead of glass** in parts of buildings, for **manufacturing parts** for machines and equipment, for **outdoor and indoor advertising**, for **containers and packaging**, etc.

Some plastics have an **adhesive** on one side that is either for affixing permanently or is removable. Sometimes highly statically charged plastics are used to simulate the same effect as adhesive. Thus the static electricity can be used instead of glue to attach plastics to smooth surfaces (normally glass). This is known as **electrostatic vinyl.**.

The **printing systems** normally used on plastic are:
- **Flexography**
- **Rotogravure**
- **Pad printing**
- **Inkjet digital printing** (using special ink for plastic media or media that have been treated so the ink can adhere to them)

4.2.2.2. Fabric

Fabric includes a wide range of **materials formed by interlacing fibres.** The fibres can be **natural** (linen, cotton, esparto grass, wool, silk), **synthetic** (plastics) or **hybrid** (combination of natural and synthetic fibres).

There are fabrics **of many different kinds with different properties** depending on the origin and treatment of the fibres from which they are formed and how closely woven the fibres are. All fabrics have some **irregularities on their surface**, as well as a certain tendency to crease and stretch, but the printing system should be capable of dealing with this. The most common applications of printed fabric are for **clothing** and outdoor and indoor **wallscapes for advertising.**

The **printing systems** normally used on fabric are:
- **Screen printing**
- **Digital inkjet or thermal transfer printing**

Vinyl is a type of flexible plastic commonly used in digital inkjet plotter printing for signposts.

Forex is a very light (lighter than foam board), rigid plastic material commonly used to mount panels for display stands.

Fabrics have been used since the origins of mankind.

Printing on fabric

Vinyl is a flexible plastic that is also stamped onto fabrics. Vinyl (whether printed or not) is die-cut using a cutting plotter and is transferred to the fabric through the pressure of a plate.

People first began experimenting with metal circa 6500 BC, when copper was smelted. Later, bronze was used, then iron.

Printing on metal

4.2.2.3. Metal

Metal is a material that is **solid at room temperature.** It **conducts heat and electricity** and **oxidises** when combined with oxygen. Metals are obtained by **treating certain minerals** in what is known as the metallurgical industry.

Many types of metal exist whose malleability, proneness to oxidation, temperature, flexibility and conductivity are all different. Almost all metals can be printed on. Some of the metals that are printed on most are **aluminium**, **brass**, **tin** and **steel**. Printing on metal is used for **utensils, tools, machinery, containers, signposts**, etc.

In addition to metals there are **metal-plated composites.** These are non-metallic materials to which metal plating is added using adhesive or through melting.

The **printing systems** normally used on metal are:
- **Screen printing**
- **Pad printing**
- **Laser engraving**
- **Inkjet digital printing** (using special inks for metallic media or media that have been treated so the ink can adhere to them)

Printing on metal is **usually very expensive**, which is why adhesive labels (which can be printed and die cut) are often used instead, or other media are printed on with metallic inks.

The origins of glass go back to Egypt and Mesopotamia in 1500 BC.

4.2.2.4. Glass

Transparent or translucent material that is hard, fragile and amorphous. Glass is made by melting down a **mixture of silica with potash or sodium carbonate (soda)** in industrial processes. The difference between glass and crystal is that crystal is formed when certain substances that have melted or dissolved

solidify and take on a geometrical shape rather than being amorphous like glass.

Glass **can have many different shapes, colours, strengths and thicknesses.** Its use is being replaced by plastic, but it is normally used to **contain prestigious products** like wine or perfume, as well as for **structural objects, buildings and vehicles.**

The **printing systems** normally used on glass are (the inks must be resistant to abrasion and detergents):
- **Screen printing**
- **Pad printing**
- **Flexography**
- **Laser engraving**

Self-adhesive vinyl is often used on windows, including shop windows, instead of printing on the glass because it is cheaper.

Fibreglass is commonly used in industry and is obtained by feeding molten glass through very fine spinnerets. The molten glass solidifies to form very strong flexible fibres.

4.2.2.5. Other non-paper media

There are other materials that can be printed on. On **leather** (treated animal hide), images can be printed when making cases, bags, book covers, etc. **Ceramic** (clay, pottery and traditionally hand-painted porcelain) is today printed on using screen printing, flexography and digital printing, mainly to make crockery. **Wood**, **stone** and other **rough media** can also be printed on using flat plotters that can adapt to the irregular surfaces.

Printing on cork

4.3. Printing inks

Printing inks are responsible for **transporting colour** from the machine's ink fountain **to the substrate**, in some systems by means of an image carrier. An ink's particular physical characteristics allow it to stick to the substrate, **affixing the colour as it dries.**

In the specific **terminology** used in the graphic arts, there is a specific way of **expressing the amount of each ink** that will be applied to the substrate. This is expressed according to the **number of inks** printed **on each side of the substrate** and using the **colour reference** of each ink.

- A **2+0** (Pantone 382 and 032) item is printed on just one side with the indicated Pantone colours.
- A **4+1** (CMYK + black) item is printed on both sides with the four CMYK colours on one side and in black only on the other.
- A **5+4** (CMYK, silver Pantone 877 + CMYK) item is printed with the four CMYK colours on both sides, with one side also including a silver ink (with the indicated Pantone colour) [4] .

There are many inks with a wide range of characteristics. **So how do we choose the ink?**

Visual or tactile characteristics
Colour, transparency and texture are determining factors when choosing an ink.

Substrate and printing system
The ink used depends on the type of printing substrate and the technique used to print on the surface. Each substrate and printing system is compatible and dries with a certain type of inks.

Durability and resistance of the printed material
How durable and resistant to light, heat, abrasion, etc. the printed material needs to be is determined by what it will be used for. The ink chosen must provide the required durability and resistance.

4. See 3.6.3. page 103

Economic criteria

Logically, the more inks that are used and more sides that are printed on, the more expensive the printing will be. Furthermore, using certain inks (particularly special inks) can make the material much more expensive to print. One may therefore choose to use more or fewer inks and a certain type of ink over another based on the budget for the project.

4.3.1. Composition of an ink

Inks are **composed of various substances** that give colour to the substrate and dissolve the ink's other components so it acquires the viscosity needed to make it adhere. The main components of an ink are as follows:

Pigments

Very fine particles that give the ink its colour. The pigments are not soluble with the vehicle that carries the ink. Pigment-based inks are more stable than dye-based inks.

Dyes

Dyes are also responsible for the colour of ink, but unlike pigments, they are soluble with the vehicle that carries the ink. Dye-based inks tend to be more transparent and brighter than pigment-based inks.

Resins

A substance that protects the colour (pigment or dye) and affixes it to the substrate. Resins also provide gloss, which is why they are the main component of varnishes. 5

Oils

Fluids that dissolve the resins. There are vegetable and mineral oils.

Solvents

Liquids that dissolve the resins to form the vehicle that carries the colour. Solvents control the viscosity and the drying. They can be of various origins, and there are many types of solvents: hydrocarbons, alcohols, glycols, esters, ketones, water, etc.

5. See 5.2.1. page 178

Additives

Ingredients that boost some of the properties of the inks. Some of the additives used are: dryers, anti-drying agents, softeners, anti-offset powders, fillers, etc.

4.3.2. Characteristics of the inks

Depending on the components of the inks, they can have different properties that determine their appearance and behaviour in the printing equipment.

Transparency

Determines the brightness of the ink.
- Transparent inks: those that allow light to pass through.
- Opaque inks: those that do not allow light to pass through.
- Semi-opaque inks: those that allow a proportion of the light to pass through.

Colour

Determines the colour intensity and sharpness.
- Gamut colour inks: CMYK - (cyan, magenta, yellow, black)
- Pantone colour inks: for producing spot colours from the Pantone guide
- Special inks: they provide other properties not related to colour.

Rheology

Determines the working temperature, density and tack or resistance to splitting.
- Viscous inks: inks with a high viscosity.
- Liquid inks: inks with a low viscosity.

Viscosity refers to how resistant liquids are to flowing.

Drying

Determines the adherence of the colour and its resistance to light, water, solvents and abrasion.
- By evaporation: the evaporation of the solvent affixes the colour to the substrate.
- By penetration: dry ink being introduced into the structure of the substrate.
- By oxidation: the drying oils in the inks become active in the presence of oxygen.

- By heat: inks that dry when heat is applied.
- By radiation (ultraviolet, infrared or flow of electrons): inks that, when irradiated, release a series of free radicals that cause polymerization of the ink.
- By moisture: these inks dry quicker when moisture or steam is applied to them.

4.3.3. Types of inks

The most widely accepted classification, which is based on the qualities of some of the ink components, distinguishes between five main types of inks.

Oil-based inks

These have a high viscosity because they contain oils. They are used for offset printing and typesetting.

Liquid inks

These are fluid, low-viscosity inks. They are used for flexography, rotogravure, pad printing and inkjet printing.

Screen inks

These have a medium viscosity (between oil-based and liquid inks). They are used for screen printing.

UV inks

These inks have a high viscosity and are dried using ultraviolet radiation. Normally they are used for screen printing.

Toners

There are dry and liquid toners, both of which contain electrostatic or electromagnetic charges. They are used for digital printing.

4.3.4. Special inks

There are special inks whose visual properties go beyond merely colouring the substrate. These include:

Oil-based inks

Plotter cartridges

Inks for digital printing

Metallic inks

Usually gold or silver in colour, or metallic colours leaning towards other hues. A Pantone metallic colours guide governs the composition of these inks.

Phosphorescent inks

Generally yellow, orange-yellow, orange, pink, green or blue. A Pantone phosphorescent colours guide governs the composition of these inks.

Pearlescent inks

These include a range of subtle pastels that change colour based on the angle of the lighting source.

Non-toxic inks

Regulated by a responsible authority, they are meant for use in proximity to food or in medical environments.

Scented inks

These can be supplied as clear varnishes or coloured inks with a variety of scents. The scents can be customised.

Thermochromic inks

They change colour based on their temperature.

Photochromic inks

They change colour when exposed to ultraviolet light.

4.4. Printing systems

Makeready refers to all the operations that must be undertaken before the first usable copies are printed.

Spoilage refers to the substrates used to set up the machine (registration, colour adjustment, etc.) before the first correct copy is printed.

Paper waste is the amount of raw materials wasted when setting up the printing and print finishing equipment.

Printing systems are **mechanisms that enable inks to be transferred to the substrate.**. Each printing system, with its characteristics, is suited to certain types of jobs, since each system **determines the quality level of the printed image**, and can be used with certain **inks and on certain surfaces**. Similarly, each method has a different **input system** and requires a specific **makeready** resulting in a fixed initial cost that varies according to the method. This makes some systems more appropriate for long print runs and others more appropriate for **short print runs.**.

There are many printing systems based on different techniques. To explain these systems clearly, we must distinguish between **two main groups** into which we can divide the systems according to whether they use an **image carrier or matrix** to transfer the ink to the media.

Image carrier systems

In these systems, to print the **image** on the substrate it **must first be drawn on another medium**, called the **image carrier or matrix.**. The ink is transferred from the ink fountain to the image carrier so it can be transferred to the substrate.

These systems typically have a high fixed initial cost since the printing plate must be created regardless of how many or how few copies will be printed. Furthermore, the makeready is usually quite **slow** for equipment that uses an image carrier, making the print runs longer (that is, a larger number of copies) and the cost per copy lower.

Depending on the characteristics of the image carrier, the system may be:

- **Planographic:** the printing and non-printing areas are at the same level.

- **Relief printing:** the printing areas are higher (in relief) than the non-printing areas.
- **Bas-relief or engraving:** the printing areas are lower (in relief) than the non-printing areas.

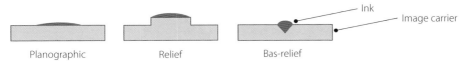

| Planographic | Relief | Bas-relief |

Based on the method of the image transfer from the image carrier to the substrate, the system may be:

- **Direct:** the image carrier strikes the paper directly, thus transferring a mirror image of the image on the image carrier.
- **Indirect:** the image carrier transfers the image to another substrate (rubber, a blanket, etc.), from which it is transferred onto the paper.

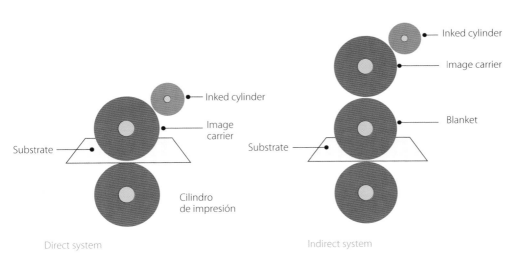

Direct system Indirect system

Systems without image carriers

The image is printed directly onto the **paper**, without the need for a matrix in between.

These printing systems generally have a **lower initial cost than image carrier systems**, since they avoid the fixed cost of creating an image carrier, and the makeready is usually faster. This means that the cost per copy for short print runs with few copies is lower with systems that do not use image carriers.

Computer

Substrate

4.4.1. Offset printing 👁️⁶

Technique

Planographic , **indirect image carrier system** based on the **lithographic** principle, in which the printing and non-printing areas differ from each other in their chemical characteristics.

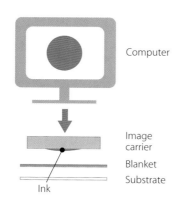

Computer

Image carrier

Blanket

Substrate

Ink

The image carrier is an **aluminium plate** in which the **printing areas** are covered in a polymer that repels water (**hydrophobic zones**) and attracts the ink (**lipophilic zones**;) while the non-printing areas of the aluminium are treated to attract water (**hydrophilic zones**) and repel the ink (**lipophobic zones**). The ink adheres to the printing areas and is repelled from the non-printing areas through a dampening system that keeps the plates constantly moist (**in wet offset**) or by the chemical makeup of the emulsion itself (**in dry offset**).

The **cylinder rotation system** of offset printers consists of various rollers that each have a different role. One of them serves to **roll the plate** which, after being inked by the inking rollers, **transfers** the image **to another rubber roller** called the **blan-**

6. Regarding the origin, see 1.2.7. page 19 and 1.2.8. page 20

ket. The blanket **transfers the image onto the paper** by pressing it against the impression cylinder. Because this is an indirect system (the ink passes from plate to blanket and from blanket to paper), the image is sharper than with a direct system, since it adapts better to any irregularities in the paper thanks to the flexibility of the rubber blanket. At the same time, this system prevents excessive wear to the plate.

Each set of inking rollers holds one colour and comprises a separate inking unit. Offset printers **can have one inking unit or more than one**: They can have four inking units, one for each colour used in four-colour printing; six units for the colours used in six-colour printing; eight units for four-colour printing on both sides; or ten for four-colour printing on both sides followed by a single coat of varnish and a special ink.

Today's offset printers **include sophisticated controls** that can be connected to workflow programmes to receive inking commands (through a CIP4 file) or colour management commands (through ICC profiles) from the prepress department. They also include measuring systems such as built-in

Offset printing plate

Ink fountain of an offset printer

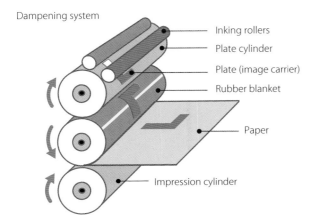

Dampening system

Inking rollers

Plate cylinder

Plate (image carrier)

Rubber blanket

Paper

Impression cylinder

spectrophotometers that check the colour of the print run on the fly and can monitor and memorise colour and registration adjustments to eliminate variations during printing.

Image quality

Offset printing can reproduce **sharp, high-quality images**. The screen ruling that can be used depends on the type of paper, but screen rulings of up to 200 lpi in wet offset and up to 300 lpi in dry offset can be reproduced.

Media feed and speed

The paper feed can be from individual sheets (sheet-fed offset) or rolls of paper (web-fed offset).

Sheet-fed offset covers a **wide range of machines of different sizes** from 35 x 50 cm to 100 x 140 cm or even 120 x 160 cm. They print between 4,000 and 15,000 sheets per hour.

In **web-fed offset, large rolls of paper are used**. The paper often passes through two blanket rollers so the two sides are printed at once. A limitation of this method is the set width. This means that the roll of paper must always have the same width, irrespective of the image size. Most web presses have a heat tunnel to prevent ink setoff and a folding mechanism built into the equipment.

They print at high speed: 15,000 to 50,000 sheets per hour.

Makeready and print runs

Makeready is a **laborious task** in offset printing (more expensive for web-fed offset than for sheet-fed offset), which is why it has a **high initial fixed cost**, making this printing system cost-effective from **500-1,000** impressions in sheet-fed offset and 15,000 impressions in web-fed offset.

Sheets

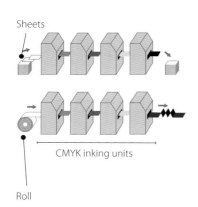

CMYK inking units

Roll

Inks

There are oil-based, transparent and semi-opaque inks using gamut colours, Pantone colours, and some special colours.

Common substrates

The substrates are normally all kinds of **paper and card stock with a weight of up to 400 g** (1 micron thick)Sheet-fed offset is used for **commercial printing** of all kinds and publishing: catalogues, magazines, books, postcards, cards, posters, etc. Web-fed printing is normally used for **newspapers and magazines** with large print runs.

4.4.2. Screen printing 7

Technique

A **planographic direct image carrier** system in which the printing and non-printing areas are distinguished by their **permeability**.

The image carrier is a **screen** formed by a fine weave of polyester or nylon threads. Using a light-sensitive emulsion and reserving the image with a film, the **non-printing areas are made impermeable** to ink while the **printing areas are permeable**. The image **is transferred** onto the **substrate using a squeegee that pushes the ink** from one side of the screen to the other.

Screen printing presses have a frame over which a tight mesh is stretched, and hinges that hold the frame to the surface on which the substrate is placed. This base may have a **vacuum system that sucks the substrate** to hold it in place. Some machines have a **mechanism** that **moves the screen around the objects** being printed when those objects are **curved**. Some machines have **drying tunnels** or ultraviolet drying units. In screen printing, each different colour requires a new film, new screen and new impression. Registration is rather complex, which is why trapping is very important. 8

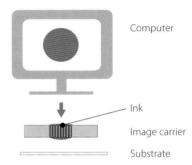

Computer

Ink

Image carrier

Substrate

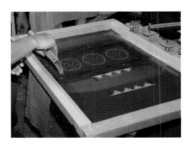

Screen printing screen

7. Regarding the origin, see 1.2.2. page 14
8. See 3.7.2. page 113

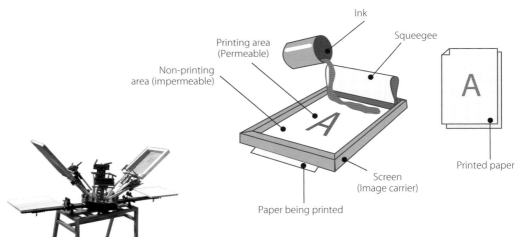

Carousel printing machine

Image quality

The print resolution depends on how closely woven the screen fibres are. Screen printing is generally used with **spot colours or quite thick screen rulings..** It can reproduce screen rulings of up to 150 lpi.

Media feed and speed

Screen printing is either **sheet-fed or individual objects are introduced** (t-shirts, bottles, etc.). It may be manual, but usually it is automatic with speeds of up to 6,000 copies per hour.

Makeready and print runs

Makeready time is fairly quick, but there is an initial fixed cost that includes producing the films, exposing the plate and registering the image. It can be cost effective for short print runs of at least 100 copies if not many colours are printed.

Inks

Screen inks and UV inks. Thick coats of ink are normally applied, sometimes becoming completely opaque. Gamut colours (CMYK) can be applied, as can Pantone colours and a whole range of special inks (UV spot varnish, textured, thermographic, etc.).

Common substrates

The substrates vary widely: paper, fabric, glass, plastic, metal, wood (including curved objects). Screen printing has been the most common technique for **printing on all kinds of clothing** as well as **posters, signs, CDs and DVDs, bottles**, etc.

4.4.3. Rotogravure 9

Technique

A **bas-relief direct image carrier system** . The printing areas are located **lower** than the non-printing areas.

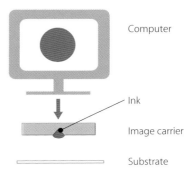

Computer

Ink

Image carrier

Substrate

The image carrier is a **copper-plated gravure cylinder** formed by **cells**. The **printing areas** are **engraved** on the copper-plated metal cylinder, which can then be plated with chromium to make it harder (hard chromed). The cylinder is inked in the ink fountain; a **doctor blade is scraped over the surface**, removing ink from the non-printing areas and leaving ink in the print areas. **The rubber impression roller** presses the paper against the gravure cylinder and the image is transferred from the cells to the substrate.

Most rotogravure machines have a **drying tunnel** that evaporates the ink. These machines often also include **folding mechanisms**. In the rotogravure machine, each **cylinder is for a different colour** and therefore part of a separate printing unit. Today, they have sophisticated colour and registration control systems.

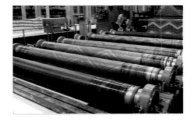

Rotogravure cylinders

9. Regarding the origin, see 1.2.7. page 19

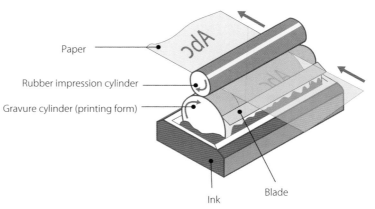

Paper

Rubber impression cylinder

Gravure cylinder (printing form)

Ink

Blade

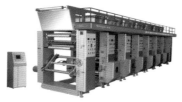

Rotogravure printing press

Image quality

Rotogravure can reproduce screen rulings of up to 200 lpi. It can therefore reproduce images with **great precision and sharpness**, although the cylinder's cell structure can be seen as dots in the printed images and text.

Feeding

The machines are fed by rolls of paper. The machines are normally very large, but unlike web-fed offset printers, they can have a variable width, thus holding rolls of papers of different widths. They can reach speeds of 50,000 impressions per hour.

Makeready and print runs

In rotogravure, the **makeready is very laborious** . To pay off the cost of the initial investment and make the most of the sturdiness of the image carrier, this method should be used for very long print runs of **200,000 or more copies**.

Inks

Quick-drying alcohol-based or water-based liquid inks. Gamut colour inks (CMYK), Pantone colour inks and special inks.

Common substrates

The most common substrates are **paper and cardboard**, which can have a lower weight and quality than is required for offset printing. This system is commonly used for **pack-**

aging and **labels** as well as for **magazines**, **supplements** and catalogues with large print runs.

4.4.4. Flexography 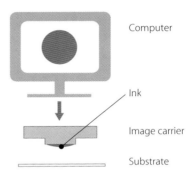[10]

Technique

A **relief direct image carrier system**. The printing areas are **higher** than the non-printing areas.

The image carrier is a flexible **photopolymer**, also called an **elastomer or plate**. The **printing areas** are **in relief** and are **inked using the anilox roller**, a metallic roller engraved with small cells that collects the ink from the inking unit and achieves a uniform transfer of ink to the protruding areas of the photopolymer. A **scraper** eliminates the excess ink and the image carrier transfers the image to the substrate, **pressing it onto an impression cylinder**.

Each colour requires a separate plate and therefore a separate inking unit with its own ink fountain and anilox roller. Flexography systems are somewhat unstable in maintaining the consistency of the colour and register, although today's flexography systems incorporate increasingly more precise

Computer

Ink

Image carrier

Substrate

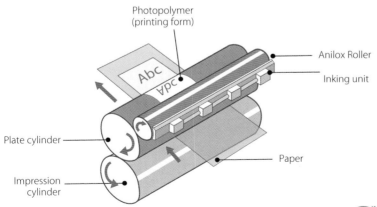

Photopolymer (printing form)

Anilox Roller

Inking unit

Abc

Plate cylinder

Paper

Impression cylinder

10. Regarding the origin, see 1.2.7. page 19

Flexography plate

Flexography printing press

measurement and control systems. The prepress technician must take particular care and take into consideration the possible consequences of deformities in the plate during printing.

Image quality

In the past, the main disadvantage of flexography has been that very fine screen rulings could not be used. As a result, thick screen rulings were used, which were very visible. **Improvements to the system**, both in making the photopolymers and in the printing mechanics, **have enabled increasingly finer screen rulings to be used.** Quality equal to that of offset printing (up to 175 lpi) can be achieved, with equally smooth tonal gradations and even sharper, brighter colours.

Makeready and print runs

Makeready time is relatively short and the plates are not too expensive, although there is a fixed **initial cost** that must be taken into account. Flexography can be used for print runs that are not too long **(from 1,000 copies).**

Feeding

The media feed is usually a web-fed system with variable width.

Ink types

Very fluid liquid inks, usually water-based but sometimes alcohol-based. Gamut colour inks (CMYK), Pantone colour inks and special inks.

Common substrates

Because it uses a flexible image carrier, flexography can be adapted to a **wide variety of substrates**. It is used on rigid, flexible and curved substrates made from many different materials: paper, card stock, cardboard, adhesive, plastic, etc. The technique is very common for **packaging and containers**, since it produces very good results on **plastic surfaces.**

4.4.5. Digital laser printing / electrophotography / magnetography [11]

Technique

These printing methods do not use an image carrier.

The digital file is sent directly to the equipment for printing. The specially charged **particles of toner are transferred to a belt or drum** via static electricity (in laser printing and electrophotography) or magnetism (in magnetography) **to form an image** on it each time a copy is printed. **As the paper moves through**, the particles of toner are **bonded** to the paper by heat from the **fuser assembly**. Each body of toner represents one of the colours of four-colour printing (CMYK).

Computer

Ink

Substrate

The digital printer applies the image directly onto the substrate, without using an image carrier, based on the data it receives from the computer. Because no image carrier is used, some or all of the data printed on each sheet can be altered. This is referred to as **variable data.**
Some digital printing equipment incorporates a **finishing unit** that can apply spot varnishing, special inks or binding.

Image quality

There is a wide range of digital printing equipment with **varying quality**. The lower quality equipment produces less sharp images with less stable uniformity of colour. The higher quality equipment produces the same sharpness as offset printing and incorporates precise measurement systems so it can comply with colour standards.

Digital printing machine

Media feed and speed

The paper feed is a **sheet-fed system** using sheets no larger than 35 x 50 cm. This printing system is not normally used for long print runs, so the print speed is not crucial; it can reach 7,000 copies per hour.

11. Regarding the origin, see 1.2.9. page 21

Makeready and print runs

The makeready for digital printing systems is **very fast**. You can almost say that the first copy is correct. Thus, because no image carrier is used, **the initial cost is very low**, making it a very appropriate printing system for **very short print runs**, and even for printing a single copy.

Ink types

CMYK gamut colour liquid or solid toner.

Common substrates

This method is used on an ever more diverse range of paper, **similar to that used in offset printing**, with a weight not above 300-350 g. However, the range of substrates is more restricted than in offset printing due to the inherent risk in some materials of applying heat from the fuser assembly.

4.4.6. Digital inkjet plotters 12

Technique

Digital inkjet plotters do not use an image carrier.

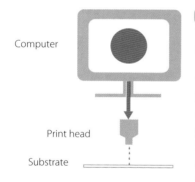

Computer

Print head

Substrate

The digital file is sent directly to the plotter, which has **print heads** each connected to a **cartridge** that supplies it with **ink of a different colour.** The heads **place droplets of ink on the paper** based on instructions received from the digital file. Some plotters, called **cutting plotters**, may include blades for dye-cutting the substrate to give it the desired form. Cutting plotters receive commands from a digital vector file indicating the outline of the shape to be cut.

Image quality

The quality of the image depends on the **print resolution** that the plotter can print (normally between 700 and 1,200 or 2,400 dpi). It also depends on the chosen substrate and the distance from which the printed material needs to be seen (if a banner will be seen from only a few metres away, it does not need to be printed at a high resolution). Higher resolutions take longer to print since the files are larger and the head needs to deposit more drops of ink.

12. Regarding the origin, see 1.2.9. page 21

Media feed and speed

The equipment can be sheet-fed or web-fed (web-fed plotters), or rigid objects can be inserted individually. Flatbed plotters may have fixed or mobile print heads. The width can be between 50 cm and several metres, and because no image carrier is needed, it can print on substrates whose length is as long as necessary. Plotters are **very slow** machines. When printing large formats, plotters can take several hours to complete an impression.

Plotter

Makeready and print runs

As with digital printing, makeready is not expensive for plotters. It is a very slow printing system, making it particularly appropriate for **very short print runs** or even single copies.

Ink types

Plotter inks are liquid and are stored in cartridges. There are many different types, according to the substrate to which they must adhere, ranging from water-based inks (inkjet or dye-sub) for printing on paper, cloth or canvas for use indoors or for printing on treated vinyl, to solvent, eco-solvent and latex inks for printing on canvas and plastic for use outdoors. Plotters can work with gamut inks (CMYK). Some print with six, seven or eight inks using the cyan, magenta, yellow and black cartridges and lighter versions of the same four colours to achieve a greater range of colours. Some plotters can also work with opaque white ink.

Common substrates

The substrates are **very diverse**: : paper, vinyl, and canvas or other textiles (in web-fed plotters); wood, plastic or cloth (in flatbed plotters). The applications range from **billboards and**

large signs to **silhouette vinyls** (in printing and cutting plotters) for heat-transfer onto T-shirts and other clothing or for sticking to glass, metal, plastic, etc. Printing plotters are also used to print certified **colour proofs**.

4.4.7. Other systems

4.4.7.1. Pad printing

A bas-relief indirect image carrier system. A silicone rubber stamp strikes the printed and inked plate, picking up the ink to transfer it to the substrate, which usually has an irregular shape and can be made from any of a number of materials. The most common applications are small objects like pens, cigarette lighters, USB flash drives, etc.

Pad printing

4.4.7.2. Letterpress printing

A direct system using a relief image carrier. Its image carrier is a metal matrix that is inked and then strikes the substrate, transferring the image to it. Between its invention by Gutenberg in 1449 and the mid-20th century, letterpress printing dominated the printing market. Today, it has almost become an artisanal or artistic method for very specific jobs. 👁[13]

Letterpress printing

4.4.7.3. Engraving techniques (chalcography, woodblock printing, etc.)

The techniques for engraving on metal, wood, linoleum, etc. are manual printing methods used for artistic purposes.

4.4.7.4. Laser engraving

In laser engraving, a laser beam is aimed at the (normally rigid) printing surface to draw an image on it.

Engraving

Laser engraving

13. Regarding the origin, see 1.2.4. page 16 and 1.2.6. page 18

4.4.7.5. Lenticular printing

Lenticular printing uses a special sheet (lenticular sheet) formed by a very dense series of identical, elongated, parallel lenses. Several images, previously divided into strips and interlaced with one another using computer software, are printed using offset or digital printing and are placed behind this sheet. When the images are viewed through the lenses, they appear to be in 3D or moving.

4.4.7.6. Transfer

A transfer (or decal) is an image printed on special paper using an inkjet or laser printer, or often using dye-sub ink, which is then transferred to one of various objects using pressure and heat (t-shirts, caps, mugs, glasses, etc.).

4.4.7.7. Hybrid printing

This combines various printing systems in a single printing unit.

Lenticular printing

Transfer

4.5. Summary diagram 4: Press

Substrates

Paper

- **Format:** Width and height
- **Characteristics that affect printability:** Colour and whiteness, opacity, brightness and gloss, smoothness, weight, porosity, thickness or caliper, bulk, grain direction and other properties.
- **Types of paper:**

 - Mechanical pulp
 - Chemical pulp
 - Rag pulp
 - Recycled pulp

 - Coated
 - Uncoated

 - Art paper
 - Self-adhesive paper
 - Carbonless copy paper
 - Textured paper
 - Paper with particles
 - Kraft paper

 - PColoured paper
 - Newsprint
 - Tracing paper
 - High-bulk paper
 - Card stock
 - Cardboard

- **The most common:**

	50-100g.	100-150g.	150-200g.	200-400g.
Gloss/matte coating		Magazines, books, posters	Brochures, catalogues	Covers, cards
Offset paper	Books, letters, envelopes			
Newsprint	Newspapers, magazines			
Paperboard				Postcards, covers
Boxboard/cardboard				Boxes, covers
Creative papers		Letters, envelopes	Brochures, catalogues	Cards, invitations

- **Uses:** Publishing, press, commercial printing, etc.

Plastic
Containers, packaging, adhesive paper, outdoor advertising, etc.

Fabric
Clothing, outdoor advertising, etc.

Metal
Utensils, tools, containers, panels, etc.

Glass
Structural elements, high-end containers, etc.

Printing inks

Terminology: 4+4 (CMYK) printed item = Four-colour gamut inks on the front and back sides.

Composition: Pigments + dyes + resins + oils + solvents + additives

Characteristics: Transparency, colour, rheology, drying

Types of inks:

- Oil-based
- Liquid
- Screen printing
- UV
- Toner
- Special inks

Printing systems

With an image carrier

- Offset
 - Planographic, indirect, lithographic
 - Matrix: aluminium plate
 - Substrates: paper and card stock, for publishing, the press and commercial printing
- Screen printing
 - Planographic, direct, permeable
 - Matrix: screen
 - Substrates: paper, fabric, glass, plastic, metal, wood, for clothes, bottles, containers, etc.
- Rotogravure
 - Bas-relief, direct
 - Matrix: gravure cylinder
 - Substrates: paper and cardboard, for containers and packaging
- Flexography
 - Relief, direct
 - Matrix: photopolymer, electromeric or plate
 - Substrates: paper, plastic, adhesive, for containers and packaging.
- Other methods: Pad printing, letterpress, etc.

Without an image carrier

- Digital
 - Laser, electrophotography, magnetography
 - Short print runs for commercial printing and publishing
- Inkjet
 - Plotter
 - Short print runs for posters, signposts, outdoor advertising, billboards, etc.
- Other methods: Laser engraving, transfer, etc.

5. PRINT FINISHING

5.1. About print finishing

Print finishing, as its name suggests, **is the process that occurs after printing to finish the production of the** graphic print product. It includes the **finalisation, fastening and/or decoration of the printed material.**

Although it is the last phase in graphic production, **finishing should be taken into account from the very beginning of the design process.** A wide variety of finishes can be used in the finishing process to give printed material a diverse range of complex characteristics; as a result, **it is a very good idea for the designer to work with the printer to determine the feasibility** of a particular application before developing the idea.

Finishing processes should be taken into account not just during the conception of the design, but also **throughout the production process**: the preparation of documents, imposition, the selection of the substrate and printing system, etc. If a particular finish is found to be unfeasible after the material has already been designed and printed, the result can be a huge economic loss and irreparable damage to the image of the designer and the print shop in the eyes of the client.

It's important to understand that print finishing processes – especially creative finishes – are quite expensive. The number and complexity of the finishing processes for a particular job are directly related to cost and turnaround time. As a result, the **budget and timeline** are **key factors that may lead to one finish being chosen over another.**

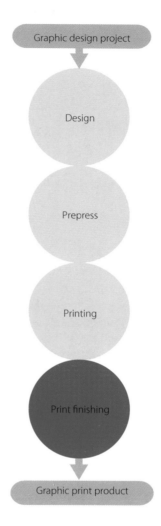

5.2. Finishes with effects

There are many types of finishes. This section describes some of the finishes most commonly used **for aesthetic purposes.**. Most of these finishes are applied by means of mechanical processes. As a result, they have certain limitations that must be understood and discussed with the printer.

5.2.1. Varnish

A varnish is a **colourless ink** applied to printed material to provide mild protection or a particular aesthetic effect.

5.2.1.1. Print varnish

A traditional offset system is used to apply print varnish to printed material. The varnish creates a protective layer that prevents the ink from staining things when the product is used. 👁[1]
After the coloured inks have been applied, a different printing plate is used to transfer the print varnish onto the paper. If the varnish plate covers the entire printed surface, the varnish is applied to the entire product. If the varnish plate has some sort of shape on it, however, then the varnish is applied only to certain portions of the printed surface. This is known as a spot varnish. Print varnishes come in three different finishes: : matt, gloss and satin. Print varnish, which is less noticeable than UV varnish, must be applied after a very precise amount of drying time (long enough to prevent smearing, but not long enough for the ink to have hardened, which would prevent the varnish from adhering properly).

UV spot varnish

5.2.1.2. UV varnish

UV varnish is applied like **serigraphic ink** 👁[2] to the substrate and dries instantly with **ultraviolet light**. It provides **greater protection** than print varnish and is similar in appearance to lamination (although it is not a plastic coating). Unlike lamination, UV varnish breaks or cracks when it is cut with a guillotine cutter, folded, scored or die-cut. Two finishes exist: **matt and gloss.**

Textured UV varnish

UV spot varnish is applied only to **certain areas of the printed material** to make some parts of the design stand out. The shape of the film negative used to create the printing screen

determines the shape of the UV spot varnish. This finish is usually combined with laminated printing to maximise the contrast.

Textured UV varnish mixes textures into the ink in the varnish to give the printed material tactile properties such as roughness, velvety effects, etc.

Matt and gloss lamination

5.2.2. Lamination

A **plastic coating** can provide printed material with **good protection** from friction, dirt and moisture, but it can also be applied for **aesthetic reasons**.

5.2.2.1. Laminating film

Printed sheets of paper can be covered with a thin plastic laminating film **on either** one or both sides. **Laminating film can withstand guillotine cutting, folding, scoring and die-cutting, and is available in two finishes:** matt and gloss.

5.2.2.2. Laminating pouches

A printed sheet can be inserted in **a plastic pouch that bonds to both sides of the paper and seals shut all around the perimeter.** This is the most protective form of lamination. Laminating pouches usually have a **glossy** finish. They are thicker and harder than laminating film and survive cutting and scoring more effectively.

Laminating pouches

5.2.3. Relief effects

In these techniques, **part of the substrate is impressed with a raised or sunken design.** Depending on the design requirements, the relief effects can be applied to an unprinted substrate or be made to coincide with a particular part of a printed image.

When designing a printed item that will include a relief effect, the designer must remember that **not all designs are appropriate for stamping**. Any relief design should **meet certain criteria, including**: it must not be overly complex; its lines must be at least 2 points thick; text must be at least 12 point for embossing or 6 point for thermography; and all relief elements must be located at least 1 cm from the edge.

1. See 4.4.1. page 158
2. See 4.4.2. page 161

Blind embossing

5.2.3.1. Blind embossing

In blind embossing, the substrate is pressed between **two hot dies** (the embossing die and a counter die) to create the desired shape. Depending which of these dies is above the substrate and which is below it, the result is either a **raised-relief** embossed image **or a debossed** – or sunken – image. Because the technique is applied to both sides simultaneously, the image produced always appears raised on one side of the substrate and sunken on the other; if the design requires that the relief image only be visible on one side, the embossed substrate can be pasted to a flat surface in order to hide the other side. Not all substrates are appropriate for blind embossing. Thick, uncoated paper usually works best, but it is always a good idea to consult with the printer.

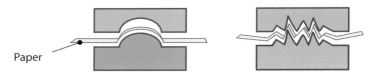

Paper

Blind embossing and debossing dies

Thermography

Some printed materials with special coatings are not suitable for use in laser printers or photocopiers, since the heat generated by these machines can melt the finishes.

5.2.3.2. Thermography

In thermography (sometimes called poor man's engraving), raised images are created by **applying thermographic powders over a special type of screen-printing ink** while the ink is still wet. After the excess powder is removed by a vacuum unit, the substrate is heated and the powder-and-ink mixture rises and solidifies. The thermographic relief effect can be either **transparent or opaque** and is available in gamut, metallic or pastel colours and **dull, matt, semi-gloss, and gloss finishes.** Thermography **cannot be applied to both sides of the page** and materials featuring this effect cannot be folded. If it is applied uniformly over a large, smooth surface, hickeys and bubbles usually appear.

5.2.4. Foil stamping

A **heated die is used to transfer foil onto the substrate**. The foil can be coloured, metallic, pearlescent, marble, holographic or some other pattern, and either **opaque or semi-transparent**. Stamping foils tend to get scratched easily. Because foil stamping is a mechanical process, the registration shifts slightly each time the die hits the foil. Text must be at least 8 point and lines must be at least 2 points thick. Foil stamping is best applied to smooth substrates and aqueous coatings that do not contain wax.

Foil stamping

5.2.5. Pasting

Two or more substrates can be pasted together and used as a single substrate. The resulting substrate is heavier (its weight is the sum of the weights of the pasted substrates) and may have different properties on each side if composed of two substrates with different characteristics. Not all substrates can be pasted together. Depending on a substrate's characteristics, it may reject the paste, leading to a bad result. The designer should ask the printer whether the desired materials are suitable for pasting to each other.

Pasting

How should a special finish be requested?
- The finish should be properly specified in the quote.
- The printer should specify how the finish should be indicated in the original file (this is generally done using a separate layer or colour).
- The desired finish should be clearly indicated in the purchase order and, following the printer's instructions, this information should be reiterated when the prepared file is submitted.

5.3. Folding

Folding with the grain

paper grain

Folding against the grain

Folding is one of the most frequent finishing operations. A product printed on a machine that includes a folding unit (a web-fed offset press, certain digital printing machines, etc.) is already folded when it comes off the press. However, a product printed on a flatbed sheet-fed machine or a web-fed system that does not have a folding or binding unit must be folded by a folding machine. Some products simply need to be folded, whereas others are folded in preparation for binding.

In either case, it is important to **take the grain direction into account**, especially if the substrate is paper. It is easier to fold paper along the grain than against it, although it is sometimes better to fold against the grain in order to avoid excessive elasticity.

5.3.1. The most common types of fold

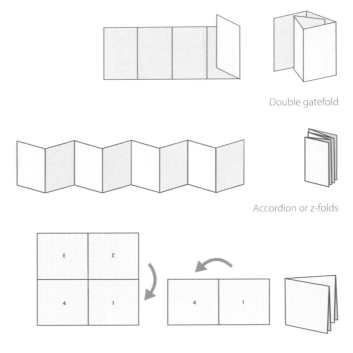

Double gatefold

Accordion or z-folds

Cross fold

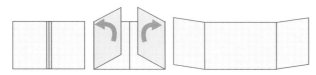

Gatefold

5.3.2. Folding machines

Folding is done on machines that work at very high speeds (up to 10,000 sheets per hour) and have numerous features and possibilities, as well as certain limitations. **Not all types of fold are possible**. The designer should always **ask the printer** about the feasibility of any unusual type of fold.

The two basic types of folding machine are knife folders and buckle folders. There are also combination folders, which incorporate elements of both. The most modern folding machines **can be connected to a computer and receive instructions from workflow software.** [3]

In a **buckle folder**, the sheet is guided between two metal plates. When it hits the stop gauge, it rebounds, buckling slightly; two revolving rollers grab the buckle and pull it downwards, creating a fold.

Buckle-folding system

3. See 2.6. page 56

In a **knife folder**, a knife presses the paper into the slot between the two revolving rollers that complete the operation.

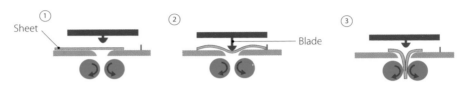

Knife-fold system

5.3.3. Fold-out products

Folding is often performed in preparation for bindin 👁 ⁺ 4, **but for certain types of products it is the final step in the finishing process.** The following are some of the most common fold-out products:

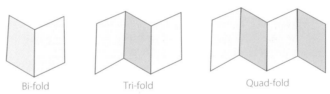

Bi-fold Tri-fold Quad-fold

Bi-fold brochure. Contrary to what the name suggests, this type of publication is folded just once, creating two panels. It is a very common brochure format.

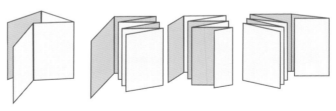

Roll folds

Tri-fold brochure. These products are actually folded just twice (either letter fold or accordion fold), creating three panels. This format is also very common for brochures. For the brochure to

Tri-fold brochure

4. See 5.5.1. page 193

close properly, the end panel that will be folded inside must be slightly narrower than the cover panel (by about 2 mm).

Quad-fold brochure. This type of publication is folded three times (letter, accordion or gatefold), creating four panels. As with the tri-fold brochure, not all of the panels have the same width; the ones folded inside are usually about 2 mm narrower than the outside ones.

Roll-fold brochure.
Products that have **more than four panels** are called **fold-outs or roll-fold brochures.** . It is very important to ask the printer about the feasibility of this type of product.

5.3.4. Alignment

When **a graphic element spans both pages in a two-page spread**, it may not match up properly where the two pages – each printed separately – meet at the gutter. In such cases, **perfect registration cannot be guaranteed** in terms of either alignment or colour. In any given signature, only the centre spread is free of this problem and can achieve exact registration. **The designers should take this phenomenon into account** and avoid placing elements requiring perfect alignment on two-page spreads other than the centre spread.

Two-page spread with and without alignment

5.3.5. Creep

When a signature is cross-folded, **the middle pages , protrude outward slightly farther** than the outer pages. This results in smaller margins on the middle pages after trimming. The number of folds and the thickness and weight of the paper determine how noticeable the creeping will be. **Designers should take creep into account and** avoid placing elements too close to the trimming margin. ◉⁵

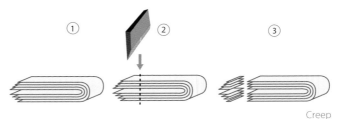

Creep

5.3.6. Scoring

A score is a crease applied to a sheet of paper using a bone folder to make it easier to fold and protect the paper from inadvertent creasing, tearing or stretching. Scoring is necessary for **paper with a weight greater than 150-170 g**, especially if it has to be **folded against the grain.**

Scored bi-fold brochure

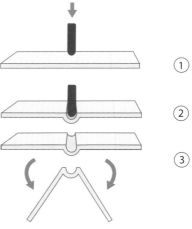

Scoring

5. See 5.5. page 192

5.4. Cutting

During finishing, most printed products are cut in some way to ensure that all the printed sheets have regular edges and that all the items are the same size. . Some products are cut several times. For example, paper may first be cut to the size of the printing machine, be cut again after printing to the size of the finishing machines, and be cut once more as a finished product. **Due to possible misalignments** in the cutting process, **a bleed and safety margin should always be left during the design and prepress processes** [6]. The designer should take these misalignments into account when designing a product that requires some sort of cutting (die-cutting, perforation, drilling, etc.) and **avoid graphics that need to be perfectly aligned** with a cut made during finishing.

5.4.1. Guillotine cutter

The guillotine cutter is a **device used to cut paper.** It consists of a bed where the paper to be cut is piled, movable gauges that hold the back of the pile in the correct position, a clamp that exerts pressure and immobilises the pile before cutting it with a sharp knife.

Today's guillotine cutters have sophisticated photoelectric safety systems designed to prevent accidents in the workplace. The most modern models **can be connected to a computer and receive instructions from workflow software.** [7]

Three-knife trimmers, which cut the head, fore edge and tail of a book simultaneously, are used in bookbinding [8].

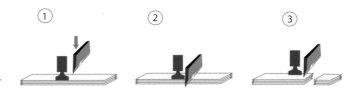

6. See 3.7.3. page 113
7. See 2.6. page 56
8. See 5.5. page 192

When the clamp is lowered, the sheets of paper are pressed together. If the ink is not fully dry it may transfer onto the adjoining page..

5.4.2. Die-cutting

This technique can be used to **cut an irregular shape** or to create an opening, perforation, score, etc. When designing a die-cut product, **it is important not to place openings too close to the edges** or to create **very thin fragments** that can tear easily. There are various die-cutting techniques, as well as techniques that achieve the same effects without a die:

With a die

Die-cutting usually involves using **steel blades** mounted on a **die** in a particular pattern to cut an irregular shape. In addition to cutting blades, the die can also have perforation and scoring blades.

Die-cutting can also be done using **acid-etched plates**. Because an acid-etched die is based on a photographic image, it can reproduce the original design with great precision.

Steel die used to die-cut a bookmark

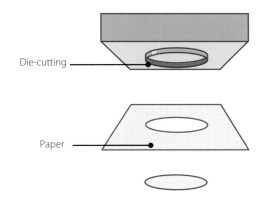

Die-cutting ———

Paper ———

Die-cutting

Without a die

Another system is **laser cutting,** . which **does not require a steel or acid-etched die**. Laser cutting can be used on almost any type of substrate (paper, plastic, leather, metal, fibreglass, etc.), but when used with certain materials it can cause burns, leading to an undesirable result. This technique is usually reserved for jobs that require a high degree of precision.

A **cutting plotter** uses its blade to create die-cutting effects by following lines drawn with vector-graphics software.

Die-cut postcard

5.4.3. Perforation

Perforation is a cutting operation that creates a series of **slits or holes in a substrate to weaken it and allow it to be cut more easily.** Perforation blades are usually used to cut **straight lines**, but if they are coupled to a steel die they can also be used to create **irregular shapes**.

A perforation consists of two elements: ties (the uncut parts of the material that remain intact) and cuts. Depending on the intended use and the type of material, the **size of the ties and cuts** can be **adjusted in order to increase or decrease the strength of the perforation.** . Perforation with less than 1 mm between cuts is called **microperforation.**

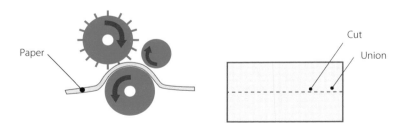

Perforation

5.4.4. Drilling

This operation is used to make **one or more holes in the sub-strate**. Drilling is usually done to allow sheets of paper to be inserted in a **ring binder**. Various standards, such as ISO 838, define the dimensions and locations of the holes to ensure alignment with the rings of the folders available on the market.

In addition to making holes for ring binders, drilling **can also be used to make holes in any location and of any size** (minimum diameter 2 mm) in labels, sample books or **other products**. Holes can be made using paper drilling machines or steel dies.

Drillings

How should a die-cutting, perforation, drilling or incision operation be requested?
- The operation should be properly specified in the quote.
- The print technician should specify how the operation should be indicated in the original file (this is generally done using a separate layer or colour).
- The desired operation should be clearly indicated in the purchase order and, following the printer's instructions, this information should be reiterated when the prepared file is submitted.

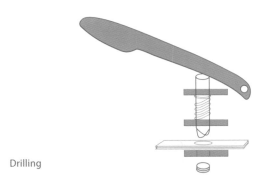

Drilling

5.4.5. Incisions

Incisions or half cuts tend to be used on **adhesive papers**, with the cutting blade cutting the adhesive but not the protective base. A cutting plotter can also be used to make incisions by adjusting the pressure and blade height so that it cuts the vinyl decal, for example, but not the plastic sheet beneath it.

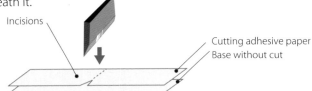

Incisions

Cutting adhesive paper
Base without cut

Incisions

Stickers with incision

5.5. Binding

Binding covers a **wide range of processes through which the pages of a publication are attached together.**

Although not all bound publications are books, the **terminology used to describe the anatomy of books** is the main terminology used to describe this kind of finishing, so it is important to know the terms used.

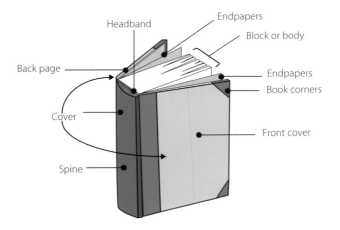

Anatomy of a book

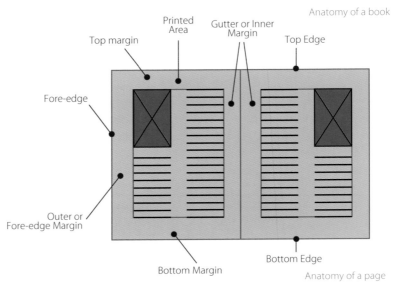

Anatomy of a page

5.5.1. Before binding

Before the pages are fastened using a binding system, two importance processes are carried out: folding and collation.

5.5.1.1. Folding

The printed sheets must be **folded appropriately with a folding machine** .

The different binding methods fasten the sheets together in different ways, but one must look at the **joints between pages** carefully and look out for any **creep**. 9

Folded sheet

5.5.1.2. Nesting and collation

Any bound publication must have gone through the prior process of collating, which involves placing the pages or sheets in such a way that when they are bound they remain in the correct order.

When the **sheets are placed one inside the other** they are said to be **nested**. If the sheets **are placed** in order **one after the other**, following the order of the collating marks introduced during the imposition, they are said to be **collated sheets.**

During this phase, an **insert** can be added to one of the sheets (for instance, a special bifolio of another size or on another type of paper), or one can **alternate**, in the collation, between **sheets with different characteristics** (different paper types, colour and black-and-white sheets, etc.).

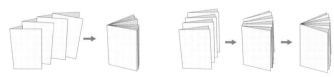

Inserted sheets and collated sheets

9. See 5.3.5. page 186

Fastening loose pages

5.5.2. Fastening loose pages

5.5.2.1. Wire, spiral and comb binding

The loose pages are **punched through the spine**; and a **wire or plastic spiral or comb goes through the holes to hold the pages together**.

Wire binding Spiral binding Comb binding

5.5.2.2. Gluing or using adhesive tape

Loose pages can be simply **glued along the spine** or **fastened using adhesive tape** or a **slide bind** that fastens them together to two separate sheets that form the covers.

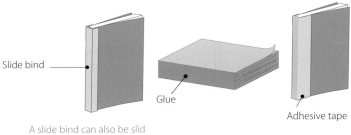

Slide bind

Glue

Adhesive tape

A slide bind can also be slid onto the entire spine, to which the covers are also attached.

Ring binders also use perforation to hold together loose pages.

5.5.2.3. Side stapling

This involves inserting two **staples into the left edge** of the publication to fasten all the pages.

Side stapling

5.5.3. Stapling through the spine or saddle-stitching

The sheets are nested together and a cover is added that has the same or a greater weight than the inside sheets. Finally, the sheets are bound from the outside using metal staples that go through all the pages to hold them together.

Stapling through the spine requires special attention to be paid to creep and joints between pages.

Stapling through
the spine or
saddle-stitching

Omega staples enable stapled publications to be inserted into ring binders.

5.5.4. Perfect binding

Although this method can be used with loose pages, perfect binding is normally used with folded sheets that are collated in order and perforated about 2-3 millimetres through the spine.. Then the spine is rough-cut and glue is added to fasten the book block. Next, the outer cover is added over the spine to which it will be glued. Finally, a three-knife trimmer cuts the head, the fore-edge and the tail to give the publication its final size.

In this perfect binding, we can see the pages glued to the cover.

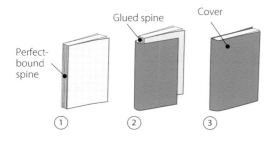

Perfect-
bound
spine

Glued spine

Cover

① ② ③

In this paperback binding, we can see the sheets stitched and glued to the cover.

The word 'paperback' is used to refer to any type of binding with a soft cover, irrespective of whether the publication is stitched or perfect bound.

5.5.5. Sewn paperback binding

The sheets are collated in order **and stitched together using thread** to **form the book block**, which is pressed to reduce its thickness. **The book block**, once sewn**, is glued along the spine to the cover**, which surrounds the book block from the title page to the back page. Finally, a **three-knife trimmer** cuts the head, the fore-edge and the tail. The covers can have exactly the same size as the book, or can be slightly bigger or folded to form **flaps** on the front and/or back cover.

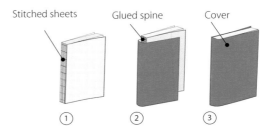

Stitched sheets Glued spine Cover

① ② ③

Paperback binding with flaps

5.5.6. Sewn hardback binding

The sheets are collated in order **and** stitched together **using thread to form the book block.** The block is pressed to reduce the thickness. It can be given a **flat spine** or a **hinged binding with a rounded spine** (a support that enables the sheets to hold together better). The spine is then coated with a strip of kraft paper which is glued, and if necessary, the spine is further strengthened with a strip of gauze. If a **headband and tailband** (a cord or band of cotton that covers the head and tail of the spine) are desired, they can be added at this point. A cotton strip can also be added as a **bookmark.**

The cover consists of three pieces of cardboard: the front plane, the rear plane and the spine. The covering is then added, which can be made out of a wide range of materials (paper, plastic, cloth, leather, etc.).

Hardback binding

The endpapers attach the book block to the covers

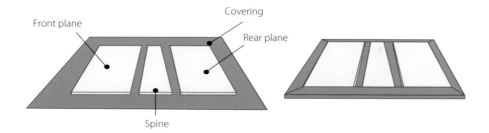

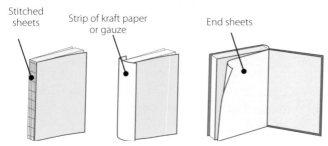

The cover is added to the book block, which has already been stitched, **using the endpapers**, which are sheets (printed or not printed) attached to the **first and last sheets of the book block** and to the insides of the covers to attach them to the book block. Some books, rather than having endpapers, attach the first and last page of the book block directly to the covers. These are called **self-endpapers**.

5.5.7. Manual binding

Some limited deluxe editions of books that are either oversize or require unusual fastening may be bound manually. Manual binding must be done by **specialist professionals** capable of carrying out all the aforementioned operations (folding, collating, stitching, making the covers and pasting them, etc.) with great care using traditional methods.

Traditional bindery workshop

5.6. Final operations

Folder assembly

Other finishes not mentioned above also exist that tend to be used in the final phase of the print finishing process. Some of these are explained below:

5.6.1. Assembly

The printed material for three-dimensional designs such as packs and folders may, once they have been die-cut and stripped, **have to be pasted and assembled to give them their final form**, if the client has asked for it to be assembled.

5.6.2. Sealing, wrapping and enveloping

Sealing involves attaching a label, seal or mark at the end of the process.

Wrapping puts a wrap (which may be printed) around the printed material.

Enveloping involves placing the printed material in an envelope or bag. This operation can be carried out with enveloping machines, provided that the envelopes are compatible with them.

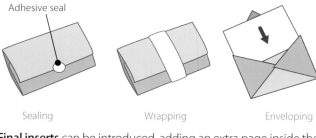

Adhesive seal

Sealing Wrapping Enveloping

Final inserts can be introduced, adding an extra page inside the bound publication.

5.6.3. On-site set-up

Some jobs, such as printing vinyls in the design of stands and displays, **require the material to be set up by print professionals** in the place where they will be exhibited. The people handling the assembly must go to the delivery location and set up the printed material according to the instructions from the designer and the printer.

Vinyl-cut decals on glass and walls often need specialist fitters to ensure that they are fitted correctly

5.6.4. Packaging

Packaging is sometimes a rather neglected task, but **it is important** because the final packaged product **will be the first contact the end client has with the product.** Specific instructions may be required regarding: how many items should be grouped together, what type of box should be used (with or without the details of the print shop, with the appropriate strengths for the method of collection or dispatch), whether the product should be palleted, whether it should be shrink-wrapped, etc. These details should be specified in the sales order.

5.6.5. Distribution and delivery

Distribution and delivery can also have specific characteristics. It is essential for the **deadlines to be met** and for the **material to be delivered in good condition.**

According to the type of job, the services of **companies specialising in zonal distribution** as well as national and international shipping and haulage companies may be required. Both if the collaboration of another company is needed or the work is delivered using the printer's own transport, a **good labelling system is needed for the printed material** specifying at least the address, contact details, and the date and time of delivery.

5.7. Summary diagram 5: Print finishing

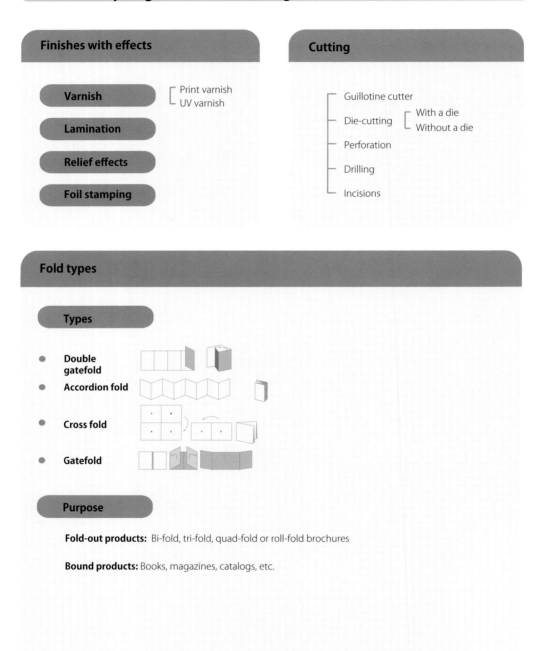

Finishes with effects

Varnish
- Print varnish
- UV varnish

Lamination

Relief effects

Foil stamping

Cutting

- Guillotine cutter
- Die-cutting
 - With a die
 - Without a die
- Perforation
- Drilling
- Incisions

Fold types

Types

- **Double gatefold**
- **Accordion fold**
- **Cross fold**
- **Gatefold**

Purpose

Fold-out products: Bi-fold, tri-fold, quad-fold or roll-fold brochures

Bound products: Books, magazines, catalogs, etc.

Binding

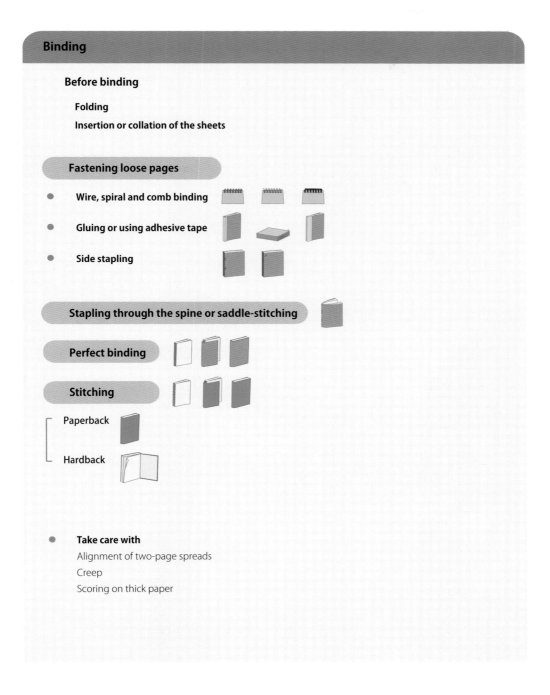

Before binding

Folding

Insertion or collation of the sheets

Fastening loose pages

● **Wire, spiral and comb binding**

● **Gluing or using adhesive tape**

● **Side stapling**

Stapling through the spine or saddle-stitching

Perfect binding

Stitching

Paperback

Hardback

● **Take care with**
Alignment of two-page spreads
Creep
Scoring on thick paper

6. OUTSOURCING AND QUALITY CONTROL

6.1. Quote, file sending and the necessary quality

Quality: The inherent property or set of properties by which the value of a thing can be judged.

When considering the quality of a final printed item, it is important to **take into account** the **terms** of the **accepted quote** and the specifications of the **sales order.** Many misunderstandings can be avoided by **thoroughly describing the desired characteristics of the job** when requesting a quote. 👁[1]

Characteristics specified in the quote:
- Name of job
- Type of product
- Format and number of pages
- Printing system
- Inks and colours
- Proofs
- Type and characteristics of medium
- Finish
- Number of copies
- Packaging
- Delivery

Another key point that has a bearing on print quality is whether the designer has **prepared the original file properly**. Equally important is the prepress technician's task of carefully checking that all of the file's properties are correct. 👁[2]

It is important to realise that **not all types of publications – and therefore, not all types of print jobs – require the same level of quality.** Logically, one should always aim for the best possible result, but not all types of products require the same degree of excellence: a brochure to be distributed in underground stations is not the same as a high-end fashion catalogue.

It is also important to remember that **higher quality implies a higher cost and a longer turnaround time.**

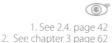

1. See 2.4. page 42
2. See chapter 3 page 62

A high-quality print job requires, among other things, better and more expensive media, inks, machines, etc., as well as a longer drying time.

It is very important to **understand what level of quality is needed and demand precisely that quality**, paying special attention to the type and durability of the printed items, the amount of money budgeted for printing, the materials to be used, the limitations inherent in the printing systems, etc.

'Quality is never an accident; it is always the result of intelligent effort.'
John Ruskin

'Quality means doing it right when no one is looking.'
Henry Ford

'In the race for quality, there is no finish line.'
David T. Kearns

6.2. Possible problems

'The man who does things makes mistakes, but he doesn't make the biggest mistake of all: doing nothing.'
Benjamin Franklin

'Recognition of an error is in itself a new truth.'
José Ortega y Gasset

'Experience is the name everyone gives to their mistakes.'
Oscar Wilde

'An expert is a person who has made all the mistakes that can be made in a very narrow field.'
Niels Bohr

There are various problems that may arise during the graphic production process, despite efforts to avoid them. This section describes, for each of the three phases of print production (prepress, printing and finishing), some possible defects of traceable origin. It is important to remember that some errors may originate in more than one phase of the process.

6.2.1. Prepress
Text-related errors
This type of error occurs when a particular font is corrupted, or when parts of the text are included in the wrong layer or separation and as a result do not appear in the final printed item. Errors of this sort can be avoided by printing and checking low-quality proofs before the final print run. ◉⌐3

Image resolution defects
If the resolution is not appropriate for the printing system being used, the images may come out pixelated or blurry. ◉⌐4

Improper colour management
If the wrong colours appear on the printed item – assuming that the printing system and medium being used are capable of reproducing the desired colours – improper colour management may be the cause. Among other factors, it is important to check the colour conversions and ICC profiles used throughout the process, maintain all machinery in stable condition, and keep measuring instruments calibrated. Colour proofs can be printed in order to detect colour shifts of this sort. ◉⌐5

Improper colour management can also lead to ink setoff problems ◉⌐6 if the total ink limit for a particular printing system and medium is exceeded. ◉⌐7

3. See 3.10. page 126
4. See 3.4. page 76
5. See 3.6.7. page 107
6. See Ink setoff page 208
7. See 3.6.2.1. page 102

Moiré effect

This is an undesirable optical effect that occurs when the screening angle is not set correctly. [8]

Blurred or invisible screened areas

If tone-reproduction limits are not respected and dot gain is not compensated, screened areas with very dark tones (90-99%) may blur together and lack sharpness, while areas with light tones (1-10%) may not be visible at all. [9]

Misregistration

There is no such thing as perfect registration. This is why the files are prepared during prepress to overcome the mild registration errors inherent in printing and finishing using the techniques of overprinting and trapping. [10]

Imposition errors

Problems with imposition or stripping can lead to pages being printed off-centre, out of order, as a verso rather than a recto or vice versa, etc. [11]

Banding

Undulating bands, most visible in areas of uniform colour, can appear as a result of problems with the CTP or CTF laser.

6.2.2. Printing

Banding

The same effect mentioned above (undulating bands most visible in areas of uniform colour) can also occur in the printing phase if the ink is too thick, if the printing unit vibrates, or if the inkjet heads are not lined up properly.

8. See 3.6.1. page 100
9. See 3.6.2.2. page 103
10. See 3.7.2. page 113
11. See 3.9. page 120

Hickeys

These are white spots that occur when small paper particles come loose during printing and stick to the printing surface of the plate or blanket, creating little voids on the printed material.

Deformed dots

This defect occurs when grid dots 👁[12] take on an inappropriate shape due to excessive pressure between rollers or because of speed differences.

Doubling (ghost images)

These are parts of the image that appear twice, the second time slightly displaced due to insufficient pressure between rollers or because of excessive distortion of the paper.

Colour shift

This defect occurs when, due to unstable machinery, the printer fails to maintain consistent colour over the course of a print run.

Misregistration

Even if the files are properly prepared during prepress to overcome the mild registration errors inherent in printing and finishing, severe, conspicuous registration errors (displaced images, visible colour separations, etc.) may occur during printing. This happens when the image carriers for each colour are not accurately lined up with each other.

Ink setoff

Ink setoff happens when ink from one page stains the back of the adjacent page. This can happen if the total ink limit is exceeded, 👁[13] if the drying systems are not used properly (quick-drying inks, anti-setoff powders, etc.) or if the printed items are handled too soon.

6.2.3. Finishing

Misregistration

In the finishing phase, misregistration can occur when cutting or another finishing process is not done according to the crop marks.

12. See 3.6.1. page 100
13. See 3.6.2.1. page 102

Finish defects

This occurs when a defective finish, or the wrong type of finish, is applied to a printed item.

Binding defects

These are the most expensive errors, because they can make it necessary to redo an entire job. Though there is always a tolerable margin of error, it is important to check aspects such as the format, adhesion, fastening and finishes.

6.3. Choosing the right print shop

Trust: 'Reliance on and confidence in the trust, worth, reliability, etc, of a person or thing; faith.'
'to consign for care.'

'Trust is only lost once.'
Nicolae Iorga

'What's measured improves.'
Peter Drucker

From the designer's perspective, choosing a print shop can be a complex decision. Price may be one criterion. Nevertheless, when **entrusting** the production of a design to a particular print shop, designers must do more than just compare prices; they should also take into account other **elements that influence quality.**

More and more print shops have begun to establish procedures intended to control, optimise and guarantee the quality of their printing processes. One increasingly widespread means of doing this, as explained in Chapter 1, is process **standardisation** followed by **certification**; . But the question remains: can only a certified company offer quality service? The answer is no. **Certification is not the only means of guaranteeing quality.** A print shop that is certified for a particular standard is guaranteed to work according to certain internationally recognised specifications; however, it is possible for an uncertified print shop to use reliable–or even standardised–processes.

The implementation of a standard involves a major economic effort. Maintenance and accreditation also entail annual costs that are unaffordable, or undesirable, for some print shops. Each company must decide for itself whether it makes economic sense, in its particular business model, to apply for certification.

Whether or not a print shop is certified, it should certainly have **control measures**, the commitment of the entire organisation, and process-status indicators. If a print shop has these characteristics, it can **engage in self-assessment and continuous improvement** in order to guarantee **high-quality service** and **customer satisfaction.**

6.3.1. Certified print shops

A company that wants to be certified must first decide to

use particular **standards** as a reference model consisting of guidelines, rules and requirements that must be satisfied. An accredited certifying organisation then inspects and validates the company's work processes. If the certifier determines that everything is in order, the company is **granted certification.**

6.3.1.1. Standards followed by some print shops
Generic standards
ISO 9001: Quality management systems
ISO 14001: Environmental management systems

Standards related to the graphics industry
ISO 2846: Colour and transparency of printing ink sets
ISO 3664: Viewing conditions
ISO 13656: Application of reflection densitometry and colorimetry
ISO 12646: Displays for colour proofing
ISO 12647: Process control for the production of prints
ISO 15930: Data exchange (PDF/X)

Other standards related to the graphics industry (e.g. paper, device calibration, densitometry and colorimetry) include: ISO 216, 2470, 8254 12641, 12642, 12645, 13655, 14981, 15076, 15790.

6.3.1.2. ISO 9001 / ISO 14001 / ISO 12647
No print shop is certified for every possible standard. In fact, it is unusual to find a **print shop certified in all three key standards**: ISO 9001, ISO 14001 and ISO 12647. A company certified in all three of these standards could **almost be considered ideal**: a 'model' print shop.

ISO 9001: Quality management systems
This standard establishes business-management guidelines. It includes a description and definition, internal rules, documentation-management requirements, the responsibility of management, management of resources (including human resources, infrastructure and work environment), product execution, measurement parameters, and guidelines for analysing data for continuous improvement.

ISO 14001: Environmental management systems

This standard describes how to implement and maintain an effective environmental-management system, as well as to navigate the delicate balance between profitability and environmental-impact reduction. It describes the general requirements, the company's environmental policy, the process of planning for the standard's implementation and launch, and procedures for checking performance and taking corrective measures.

ISO 12647: Process control for the production of prints

Issued in several different parts, this standard establishes the technical specifications and tolerances for colour reproduction of various sorts: offset printing, newsprint, gravure printing, screen printing, flexographic printing, and the printing of digital proofs. The content of this standard may overlap with that of other standards related to the graphics industry.

Parts of the standard:
- **ISO 12647-1:** Parameters and measurement methods
- **ISO 12647-2:** Offset lithographic processes
- **ISO 12647-3:** Coldset offset lithography on newsprint
- **ISO 12647-4:** Publication gravure printing
- **ISO 12647-5:** Screen printing
- **ISO 12647-6:** Flexographic printing
- **ISO 12647-7:** Proofing processes working directly from digital data

6.3.2. Uncertified print shops

An uncertified print shop is also capable of guaranteeing quality service. The main difference between a certified company and an uncertified one is that an accredited certifying body has guaranteed that the certified company follows particular standardised procedures. **How can a designer evaluate an uncertified print shop?** Taking certain parts of the ISO 9001, ISO 14001 and ISO 12647 standards as a guide, the following sections describe characteristics that a print shop should possess to guarantee a high-quality service. A company may develop an alternative system (other than standardisation) that makes sense for its particular characteristics and is equally capable of providing customer satisfaction.

6.3.2.1. Customer relations and service

Although they may be **intangible** and difficult to measure, characteristics such as **reliability, commitment, good communication, advice and friendliness** are assets that help win the trust of customers.

6.3.2.2. Management

A company can improve its operations by tenaciously striving to improve the areas of **management, administration and record-keeping**.

6.3.2.3. Environment

A print shop should consider making **an environmental commitment** to using the least harmful products available, saving as much energy as possible, and minimising and properly disposing of waste.

6.3.2.4. Process control

Constant process control that covers both the execution of tasks and the conduct of the work team should ensure **stability**. By carrying out frequent checks, tests and corrections, a company can guarantee that its work takes place under constant production conditions. This ensures **repeatability** and therefore makes it possible to **maintain a consistent level of quality over time.**

6.3.2.5. Equipment maintenance

It is important to frequently **calibrate and perform maintenance on machinery** (computers, printers, plotters, CTP, CTF, plate burning machines, printing equipment, etc.) **and measuring instruments** (densitometers, spectrophotometers, paper scales, balances, etc.)

6.3.2.6. Lighting conditions

In areas where decisions about colour are made (machine controls, workstations where proofs are examined, etc.), the lighting should be neutral. The most common standard, known as **D50**, has a colour temperature of **5,000 K**.

6.3.2.7. Preflight process

It is essential to have some sort of preflight system, which checks all native files and PDFs – usually with some degree of automation – to make sure that no errors have been introduced during document preparation. A PDF/X certification system may also be in place. [14]

6.3.2.8. Tolerances

A print shop needs to establish the acceptable tolerances for its production system. In other words, it must determine the **minimum and maximum values** (dot-gain percentages, ΔE colour differences, paper weight differences, etc.) **that an optimal-quality printed item is allowed to have.** The ISO 12647 standard establishes two different types of minimum and maximum tolerance values:

- **Deviation:** The difference between the OK print and a proof, or between the OK print and the values of the standard.
- **Variation:** Variation within a print run. For at least 68% of the prints, colour differences with respect to the OK print must not exceed the pertinent variation tolerances.

6.3.2.9. Variable inspection

To **ensure the stability of the process and guarantee repeatability**, certain **variables** (pertaining to the image carriers and the printing machines) should be **inspected and kept as constant as possible** within the established tolerance limits. This is done by **using calibrated instruments to measure** the various parameters that affect variability. The tasks involved in variable inspection include the following:

Stability of substrates

The printer should check for alterations to the substrates to make sure that they fall within the established tolerance limits. The process of manufacturing a substrate leads to variations in colour or whiteness, weight, thickness and texture. Using the appropriate measuring instruments (spectrophotometer, colorimeter, paper scale, micrometer, etc.) it is possible to determine the degree of deviation.

14. See 3.8.1. page 114

Screening variables

The printer should use particular grid dot shapes, screen rulings (or frequencies) and screen angles and verify their stability.

Tone-reproduction limits

Dot-gain percentages need to be kept within the established tolerance and tone-reproduction limits in order to prevent dark areas from becoming blurred and light areas from vanishing completely. 15

Total ink limits

The printer needs to ensure that the total ink limits for a particular printing system and medium are always respected. 16

Registration

The distance between the registration marks should be minimised, and always kept within narrow deviation limits. 17

Colour management

The printer should use densitometry and colorimetry techniques to check that the ink colours are stable to ensure that the colours appearing in the final image are within acceptable ΔE values and to obtain a neutral medium grey. 18

6.2.3.10. Reliability of colour proofs

Colour proofs should be printed to guarantee the best possible simulation of the printing parameters. Once the client has signed off on a colour proof, the printer needs to make sure the items produced in the subsequent print run match its visual characteristics as closely as possible.

6.2.3.11. Validation of print finishing services

A system should be in place to ensure that all suppliers, including those involved in finishing services, are held accountable for any problems that may arise.

15. See 3.6.2. page 102
16. See 3.6.2. page 102
17. See 3.7. page 112
18. See 3.6.7. page 107

6.4. Summary diagram 6: Quote and quality

Quote

- Care should be taken when drawing up a quote and sending files; all characteristics should be clearly specified so that their quality can later be assessed.

- The quality should be appropriate for the type of printed product and the available budget.

Possible problems

Typefaces

Resolution

Colour management

Screens (moiré effect, blurring, deformed dots)

Registration

Imposition (alignment, creep)

Banding

Hickeys

Ink setoff

Binding defects

Evaluating a print shop

Certified print shops

- ISO 9001: Quality management systems
- ISO 14001: Environmental management
- ISO 12647: Technical specifications for printing

Certified print shops

- Good customer relations and service
- Good process management
- Respect for the environment
- Process control
- Well-maintained equipment
- Neutral lighting conditions
- Meticulous preflight
- Checking of tolerances as well as printing and finishing variables
- Use of colour proofs
- Validation of outsourced services

7. PRINTED VS. DIGITAL PUBLICATION

7.1. Another form of publishing

Without understanding where we are we cannot even guess where we are heading

So far, this book has talked about the current state of the graphics industry. It has **described processes, techniques and technologies,** observing that the trend is towards leveraging **increasingly automated and standardised procedures** that are more and more **environmentally friendly,** and which **foster globalisation and offshoring.**

Publish: make public, make evident, make known, manifest, reveal, disseminate, convey.

We have also seen how the Internet, besides bridging distances and making it possible to work online, is driving a necessary reinvention of print production. In chapter 1 👁 **¹** we indicated three consequences of the advent of the web that directly affect the graphics industry:

1. It has brought about **new forms of communication and interaction,** making it possible to work online.
2. It **broadens the concept of publishing** beyond paper with the proliferation of digital publishing.
3. It **changes the role of the reader/viewer to that of an active user** who interacts and participates.

 The World Wide Web was created around 1989 by Tim Berners-Lee (an Englishman) and Robert Cailliau (a Belgian) at CERN (the European Organization for Nuclear Research) in Switzerland. Berners-Lee and Cailliau built on Ted Nelson's earlier idea of using hyperlinks (a project from the 1960s called Xanadu) to find a data storage and retrieval system. The new solution made it possible to link information through the Internet and retrieve it through an interpreter: a browser.

The Internet does not only affect the graphics industry; it entails a different way of reading images and text, as well as a new approach to producing them; in other words, a different way of structuring reality and therefore **a different way of understanding the world.** We face a changing reality, and a society with new needs that must be met: It is vital to **devise new business models that provide solutions for these needs. What is this new reality like?** We will try to answer that below by developing the three themes we have already mentioned.

7.1.1. New forms of communication

The Internet gives us the framework for a large digital village, bridges distances (everything is nearby) and entails a change in interpersonal communication, which can now be multidirectional, synchronous or asynchronous. But it also revolutionises the media, understood as all channels for transmitting information in any communication mode: verbal (oral or written), visual, audiovisual, musical, etc. It transforms how people

get information and learn; now instead of mass media (the same for everyone), the media are singular and customised.

7.1.1.1. Multidirectionality

The Internet supports **simultaneous or synchronous two-way communication**, such that sender and receiver switch roles constantly (as if talking on the phone), as well as multi-directionally in a conversation with several people at once (in a chatroom, for instance). But it also allows **asynchronous conversations** (via e-mail or by participating in an online forum, for example) in which recipients will reply after reading the message, when they know the answer, or simply whenever they feel like it; but not necessarily immediately after the question has been asked.

These new multidirectional relationships in which **we are all** simultaneously **senders and receivers** of messages occur not only in **conversations with other individuals**, but also while **browsing the web**. Users who merely visit a site to read news, watch videos or hear music are also senders of messages, since they become sources of information for applications that record their browsing and build traffic logs that give constant feedback to the organisations behind the sites.

Sender
Receiver

Sender
Receiver

Two-way communication

Sender
Receiver

Receiver
Sender

Receiver
Sender

Receiver
Sender

Multidirectional communication

7.1.1.2. Immediate access to information

The Internet is a tool that **grants quick, relatively inexpensive access to huge amounts of up-to-the-minute information on any topic at any time**. The Net and the information and communication technologies (ICTs) play a particularly important role and are now one of the **driving forces behind** what is known as **the information society**. The information society is defined as a change in the functioning of societies, which began around 1970. It shifted wealth generation away from the industrial sectors to the service sectors, which instead of producing tangible objects were devoted to generating, storing and processing all types of information.

'The Net is not a megaphone. The Net is a conversation.'
J.D. Lasica.

1. See 1.3 page 24

In this context in which so much information is accumulated, **indexing and search engines are essential for managing data** and **filtering based on the users' interests.**

7.1.1.3. Changing the concept of distance
How far is far?

'At the dawn of the new digi-tal communication, society has truly become a tiny village... a digital village.' Flores Vivar and Miguel Arruti

The information accessed on the web can be generated in any corner of the world that has a connection. Thus we may be reading an article or watching a video recorded by some-one thousands of kilometres away and we can also be talk-ing with that person and seeing him or her in real time, even if there is an ocean between us. **The concept of distance has changed** completely; **the world is a small digital village.**

7.1.1.4. Singularity

Who is closer to you: a rela-tive who lives in the same city, whom you only see once a year at Christmas dinner, or your friend in Berlin, with whom you chat via webcam at least once a week?

When discussing the media, it is said that **television drove the reign of the mass media**: those media (the press, radio, televi-sion and the publishing industry itself) that are received simul-taneously by a large audience.

Though it is true that today the Internet has a more massive reach than any other medium, it cannot be said to function as a 'mass medium'. Through the **Internet** a user can access the same content as everyone else but can also choose to visit just the content that most interests him or her. This ca-pacity for personal choice, **which fosters both singularity and difference**, is what the Net encourages. **This distinguishes it from the groupthink of media such as TV, radio and the press**, which treated all viewers, listeners or readers the same. Content is sent to and received by each individual separately in a customised fashion, because each individual is unique and constructs his or her lifestyle to measure, a style different

'The masses destroy all that which is different, individual, singular, qualified and selected.' José Ortega y Gasset

from other people's.

There is no longer a single audience, or large target audiences; **there are as many audiences as there are individuals.**

7.1.2. Changing the concept of publishing

With the Internet, the concept of publishing has expanded beyond paper; it has become hybrid publishing that reaches the public through different media and combines different communication modes at the same time: verbal (oral or written), visual, audiovisual, musical, etc. The web also alters the public media space: a space in constant flux that all users now construct collectively among ourselves.

7.1.2.1. Variable, changeable

The structure and technology of the Internet favour the **variable, changeable nature of this medium**. All online objects are digital, have a mathematical description and therefore a numeric representation. These representations make up units that can be fragmented into modules. A group of modules can function as a unit, but if any element is swapped, replaced and/or deleted, a different unit results: a new or changed version.

'A new media object is not something fixed once and for all but can exist in different, potentially infinite, versions.'
Lev Manovich

These **changes** may be **produced through automated processes** (there is a multitude of online processes that need no human intervention and which generate constant changes on the web). These variations **can also be brought about through human actions**. The user's active participation in generating content **eliminates the concept of a static publication** (like the multi-volume encyclopedia on the bookcase at home). As a result, **online publications can always be living documents, constantly under construction,** never finished, **ever variable and changeable**.

7.1.2.2. Metamedia - multimedia

The Internet is a medium that **combines the characteristics of the previous communication media**: the written press with any text on the Net, photography on any blog, book pub-

When languages change, the world is also transformed. 'The limits of language are not the limits of the world.' Ludwig Wittgenstein

lishing for e-books, radio and TV with any streaming media, phone via voice chat, etc. The Internet makes it possible to combine all existing media; it is their heir and shares their traits, which is why it is rightly referred to as a **supramedium or metamedium**.

In any case, the Internet **cannot just be considered the sum of all media**, because besides combining them **it opens up other new communication channels. Online publications** are **hybrids**, combining different communication modes and resources: text, voice, video, animation, music, etc., **yielding new multimedia communication modes** yet to be explored. The fractal structure of the Internet gives rise to **non-linear publications** that are not read from start to finish, but rather are configured into modules that can be consulted separately, encouraging jumps to other references through links, in a route that each user chooses at will by clicking here or there. They also make it possible to have several routes open at once, tracking several topics simultaneously.

7.1.2.3. Changing the public media space

Therefore we must remember that not everyone has Internet access and that some things cannot be found online. The fact that some things are left out of this great digital village does not mean that they do not exist.

Online **we can all** converse, **publish** a text, a photo or video; it does not require a huge budget or a high level of technical knowledge to make something public. Anyone with Internet access can put whatever they want before the public, and not only that, can also **distribute it** quickly. E-mail and social networks make it possible to spread information to hundreds of contacts, and from those contacts to others, so that it covers the length and breadth of the planet in just a few hours. Whereas before, under the reign of the mass media, the public media [2] space was delimited by what appeared on TV, in books, on the radio and in the press, now **this public space** has expanded enormously; **we construct it among ourselves because we are all publishers: we create, publish and distribute**. In this new public space, **public opinion** is as important as before, but now the elements that construct it **consist** of **many more voices**.

2. See 7.1.1.4. page 222

7.1.3. From reader/viewer to user

The web turns the reader, viewer or listener into a user. With television, books and radio, the chance of participation is so slim that the receiver of the information is considered a passive agent of communication. Online, however, **the user** can converse, wander at will through countless sites, spend more or less time in one spot or another, change and add content, with the result that the user no longer receives information passively from the medium, **but is an active agent of communication**. In a conversation with someone in a chatroom, videoconference or forum, the communication is two-way, which requires the users' active participation. The user is also a dynamic element when generating content (writing in a blog, publishing a photo, leaving a comment, etc.) The user is also active while browsing, which entails deciding what pages to visit, what routes to take, how much time to invest in each section and what section to skip.

Given the traits identified in the two previous items [3], which describe how the Internet has opened up new forms of communication and a new concept of publishing, we may say that **users** today are **active individual agents** of a **multidirectional metamedia** encompassing the **world** in a large **digital village**. Using multiple communication modes, they converse, are informed, and distribute, create and change content, participating in the **construction of a shared public media space** that we all build among ourselves and which is in **constant flux**. Below we shall see some of the traits of **today's user: the true leading figure of the Net.**

User

1. 'a person or thing that uses'
2. 'the continued exercise, use, or enjoyment of a right, esp in property'

7.1.3.1. Customisation

Web 2.0, also known as the social web, is a second generation of web technology built around a range of services such as social networks, blogs, wikis and folksonomies, which encourage collaboration and quick, effective information exchange among users.

3. See 7.1.1. page 221 and 7.1.2. page 223

In this environment many online applications, besides fostering participation and content generation, promote **customisation of the appearance of the information.** The user can personalise an application's visual aspects (amount of information, layout, colour, typography, etc.) so that it displays exactly what the user wants to see in the desired format: the user creates the content and also shapes it as he or she likes. Though of course, the user's actions are limited by what the applications allow (if it doesn't offer a gadget that lets us do something, we cannot do it). However, it is worth noting that more and more systems **ask users to make suggestions and vote** and therefore try to satisfy their demands more directly.

7.1.3.2. Diluted privacy

Internet use is starting to erase the boundaries between public and private. The user's active participation has opened up a huge public media space that has also devoured some private spaces. **Public things become private** (we have the world in our mobile phone) **and private things become public** (we show our birthday parties to the world). Having an online presence means publishing certain information (which is more or less personal, depending on our choices) which will then circulate with little control on our part.

Privacy: the condition of beng private or withdrawn; seclusion'

As the private and the public merge, the boundary between **personal and professional also dissolves.** Some crossover between these spheres is not new, nor is it specific to the Internet; our professions have played an important role in constructing our identity for a fair number of years. But today, the web supports and intermingles many personal and professional aspects of life (we check our work e-mail from home, chat with friends while at work, share our social network profile with people from both areas of our life, who can also visit our personal blog, etc.)

7.1.3.3. Multitasking

It has been said that the Internet is not a linear medium; rather it is like a spider web of interrelated links in which a multitude of routes can be open at once. This structure, in the form of an indexed web, seems to resemble human thought. Maybe that is why users have a growing tendency to carry out many activities at once (having several webpages open in the browser, being connected to several chat services, having the e-mail client open, running an online music player, downloading a video and so on). The medium increasingly allows **users to perform different tasks at the same time**, placing one in front of the other and combining them while paying attention to them all: this is **known as multitasking**.

We humans connect information in our thoughts; we abbreviate words, use mental images to illustrate certain concepts, and connect this information using our own criteria of meaning. This is what Vygotsky called 'inner speech'.

7.1.3.4. Connectivity

Originally access to the Internet was achieved only through computers: relatively heavy devices typically installed in a specific location (even if they were laptop computers) where they were connected and used. Nowadays there is a proliferation of portable devices that can connect to the Internet constantly, meaning that users are **always online**. (People no longer wait to get home or arrive at work before checking e-mail, entering a chatroom or seeing the latest news; it is all available anywhere at any time).

Connectivity: A device's ability to be connected without needing to be hooked up to a computer.

7.2. Publishing for users

As seen in the previous item, users customise their journey through the web; they share their privacy in varying degrees, can perform many tasks simultaneously, and are online constantly. **These modern users occupy a much more important position than the readers/viewers of a few years ago:** : today's users decide, manipulate, create, reject, transform, publish, comment, and in short, have much more power because they are the true centre of communication.

'When I design, I don't consider the technical or commercial parameters so much as the desire for a dream that humans have attempted to project on an object.'
Philippe Starck

Although design methodology inherently must take into account the object's functionality and its relationship with the human being who will use it, the nature of the Internet has encouraged **web design** (understood as design for electronic devices) **to give still greater consideration to the user's role**, for three possible reasons:

- Since the Internet is a relatively new medium, **educational effort** has been needed to teach users to navigate it; care has been taken to make things simple for users (who otherwise will close the page and move on to another)
- **Users' actions and reactions can be measured more effectively**. Tracking clicks and browsing patterns can yield immediate feedback on how people use the interface and how much it interests them, which can be used for instant updates and redesigns.
- The user's preferences have become much more important. As the protagonist of the public media space, and therefore the protagonist of public opinion, the user has more power to support an online object (by recommending it) or reject it (by criticising it).

Web design is now fully integrated into our lives: children are born into homes with Internet connections and can use a mouse by the time they take their first steps; Adults, in turn, without realising it, have internalised the Internet's communication modes. This is why notions related to web design – such as usability, usefulness, accessibility, interactivity and interface – extend beyond the Internet and are beginning to affect all types of design.

Below we will explore some **web design terms that are now starting to expand beyond the Internet to pervade other areas of design, including printed publications.**

7.2.1. **User-centred and usability-centred design**

User-centred design is an approach to the design process in which **the needs, wishes and limitations of the end user are made a high priority** at every step of the creative process, with special attention paid to the objects' usability and usefulness.

Usability is the ease with which people can manipulate any man-made object to achieve a particular goal; it studies the perceived efficacy of interacting with that object. **Usefulness** is an object's **quality** of **being useful and practical** in its specific application.

User-centred design requires not only designers to analyse and foresee how users will be most comfortable using an interface, but also testing with real users to observe their behaviour and their learning curve. Even while we try to optimise and adapt the interface to how people can work, wish to work or need to work, without forcing them to change their way of doing things, **we must always leave room for experimentation, innovation**, challenges and play, so that new communication modes and channels will continue to be explored.

'If you think your users are idiots, only idiots will use it.'
Linus Torvalds

The **World Wide Web Consortium (W3C)** is an international association that develops standards aimed at maximising the potential of the Internet.

7.2.2. **Accessibility**

Accessibility is **the degree to which everyone can use an object**, visit a place or access a service, regardless of the person's technical or physical abilities.

Accessibility works to:
- Facilitate access for users with disabilities.
- Improve access from anywhere using any device.

7.2.3. Interactivity

Interactivity results from **reciprocal actions between two or more objects or individuals**. Working from this definition, we can distinguish between two types of interactivity:

Relationship between user and device
Interactivity refers to the **relationship between a human and a device that must be manipulated to operate it**. This interactivity resides in how the object interacts with the human being. (In an MP3 player, for instance, the interactivity would consist of how we navigate through its commands, choose songs or control the volume, while in a book it would consist of how we open its cover, turn its pages or pick it up to carry it somewhere else.)

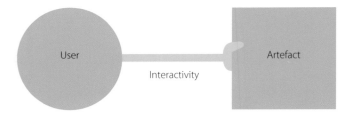

Interactivity understood as the relationship between a user and a device.

Two-way communication
In the context of communication, interactivity is considered
a two-way or multidirectional communication process in
which the (two or more) parties to the communication con-
stantly swap roles as sender and receiver.

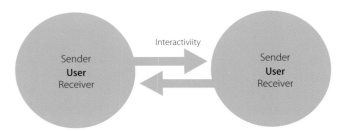

Interactivity understood as two-way communication.

The various **levels of interactivity** can be measured **by how
much the user participates:** : How and how much must **the
device be manipulated** to be able to use it? How much does
it support **multidirectional communication** with other indi-
viduals or objects?

The word 'interface' refers to a common boundary between two things.

The monitors of devices connected to the Internet are interfaces between the user and everything that can be found online.

The graphical user interfaces of devices connected to the Internet have icons and menus on the screen enabling the user to access and browse the web.

7.2.4. User interface

An interface is a device that **enables communication between two systems that do not speak the same language**. Restricted to technical contexts, the term interface is used to define the set of connections and mechanisms that make communication between two systems possible.

The **user interface is the means** by which a user can communicate with a device. It is the surface of the device which is manipulated by the user: the place where interactivity takes place. It includes all the points of contact between the user and the object.

A **graphical user interface (usually referred to as a GUI)** uses a **set of graphical objects to represent the information and the available options**. It involves the presence of a visual device (such as a screen) that displays the layout of the interactive elements. It is the visible face of a device.

From this perspective, the tab we lift to open a package could also be considered a user interface.

The graphical user interface of a package has a symbol, such as an arrow, to guide the user in handling the object.

7.3. Enabling digital and print publishing to coexist

Today, designing a book is not the same as it was thirty years ago: the recipient is no longer simply a subject who reads the book's content, but rather a user who interacts with an artefact.

In 2009, some US newspapers stopped publishing on paper. Copies of the last paper editions are now displayed under glass like museum exhibits.

Because of the features described in the previous sections, we must now begin to work within a new paradigm. Communications are taking place in a new context. New publishing media require new visual languages; the 'receivers' of information have become active users. As a result, designers have had to reposition themselves and focus their interest on the users.

Although it is impossible to predict the future, in the following sections we will attempt to extrapolate the graphics industry's prospects from its current situation.

Today, the graphics industry continues to print newspapers, books, magazines, brochures, catalogues, etc., but its production recently seems to have stopped growing and indeed begun to shrink. Growth in e-book sales has become a reality. Apple's recently launched iPad signals a shift towards the development of digital reading devices that promote interactivity by allowing users to interact with different kinds of multimedia files (video, animation, links, etc.) in various ways (making notes, underlining text, etc.). Change is coming more slowly in the field of signage and outdoor advertising, but even this area seems to be moving towards large electronic devices that make paper unnecessary.
Everything seems to indicate that in a variety of settings (education, work, leisure, advertising, etc.) people will increasingly be **accessing and handling information using Internet-enabled mobile devices, which are becoming lighter and less expensive, have longer battery lives, explore different multimedia languages, and take advantage of interactivity.**

How is print publication positioning itself in this context? And how can it find a way to coexist with digital publication?

7.3.1. Print publication
In marketing terms, one way to ensure the success of an

advertising campaign is to highlight the characteristics that differentiate a product or brand from its competition: this means figuring out just what makes it different and special. If we think in these terms, print production can be considered to offer an **added tactile and sensory value** that cannot be equalled or surpassed by any digital reading device. A good strategy for marketing this difference could be to highlight the smell and feel of paper, the ingenious die-cutting of certain printed products, and the effects available in different finishes.

At the same time, it is important to remember, as explained above, that print publication is now starting to be designed using the parameters for web design. As a result, the **user** of a particular printed object **plays a central role in its design.** The terms usability, usefulness, accessibility, interactivity and user interface [4] are being used with increasing frequency in the context of paper-based design to describe how an object is supposed to be handled, how convenient and practical it is to use, what limitations users with some sort of disability may encounter when using it, what elements of interactivity it possesses, what graphic interface ingredients promote this sort of interaction, whether it provides some sort of feedback, how it encourages active user participation, etc.

The following sections describe a possible approach to some printed products that **possess added sensory value and encourage user participation** and which we therefore believe are **capable of coexisting alongside digital publication.**

7.3.1. Printed objects

Some printing systems (such as screen printing, flexography, rotogravure and pad printing) are capable of printing on irregular or flexible surfaces and can therefore be used to print on a wide variety of objects (bottles, bags, T-shirts, pens, etc.). In these systems, starting up the printing machine can be quite expensive, so the minimum number of units at which it is cost-effective to place an order can be rather high.

This type of production differs from multimedia in the sense that it results in tangible objects.

It responds to users' need for personalisation.

4. See 7.2. page 228

Printed objects

Advances in digital printing have made it worthwhile to order very small print runs either on paper or on other substrates. Thanks to printed and non-printed vinyl-cut decals, heat transfers, iron-on transfers, and plotters capable of handling flexible, irregular or highly varied media, it can now be cost-effective to order printed objects in very small quantities.

We are also seeing a **trend towards allowing users to personalise or customise objects**. In much the same way that they personalise their blogs or social-network profiles, users can now create their own caps, T-shirts, mugs, plates, bowls, etc. The fact that these products are tangible objects is a distinguishing factor that multimedia products cannot compete with.

Objects of this type can be personalised and ordered using online print-on-demand services.

The value of a book as an object is derived from the end user's demand.

7.3.1.2. Print-on-demand and web-to-print

The publishing industry has developed these printing technologies in response to its problem of having to store numerous copies of a product without knowing for sure whether they will be sold or remain in stock. The print-on-demand publication methodology is usually, though not exclusively, used for books. In this system, copies of a book are not printed until a firm order is received; as a result, the publisher can be sure that each printed copy is sold. [5]

Although any printing technology can be used in print-on-demand, **digital printing is used most frequently** because it is the most cost-effective system for short print runs that produce just a few copies, a single copy, or several copies with a few minor changes made to each one.

5. See 4.4.5. page 167 and 4.4.6. page 168

Print-on-demand is **used in the publishing industry to print books, to reprint previously published material**, and to enable **any individual to write, design and publish his or her own book**; print-on-demand websites allow users to download very simple desktop publishing programs and use them to prepare the layout of a book for subsequent printing. In addition to books, print-on-demand is also used for **other printed products: catalogues, calendars, photo albums, packaging** and even **printed objects.**

Most print-on-demand jobs are ordered through **web-based services with automated administration processes that allow users to monitor their orders electronically**. This type of system is called **web-to-print.**

7.3.1.3. Large-format printing

The field of signage and outdoor advertising is moving towards the development of large electronic devices. Nevertheless, due to the high cost of these devices and to advances in digital plotters, large-format printing remains a growing field. Because printing can be done on many types of paper, cloth, canvas and vinyl, as well as a wide variety of rigid surfaces, it is possible to produce, in print runs of very few copies, high-quality **banners, display stands, panels and vinyl decals** for use in trade-fair stands, exhibitions, signage, etc.

Some users seek the tactile experience that only printed media can offer, and in the design process the user is increasingly considered to be part of the work.

Index Book stand

This type of production maximises differential sensory added value.

The user is considered to be an essential part of the work.

7.3.1.4. Book object

A book object is intended not only to be read in the ordinary sense of the term, but also to provide a series of dynamic sensory experiences derived from its three-dimensional nature. Book objects talk, ask questions, engage in dialogue, interact with people, insist on the active participation of the user, and require collaboration in order to be complete. Book objects can be seen as an exception in the publishing world in the sense that, rather than possessing the traditional characteristics of published works, they satisfy packaging and merchandising criteria**.**

Book object

The fact that they are tangible objects sets them apart from digital production. The designers consider how the user will handle the object.

Many electronic products, such as Apple's iPhone, are presented in deluxe packaging.

This technological approach merges printing with objects, transforming them into electronics.

The development of a work of this sort (whether a book object, a catalogue, a magazine or another type of printed object crafted along the same lines) requires a **major creative effort** in terms of the concept, design and development of the idea, as well as **impeccable print production** featuring strict **control over the prepress, printing and finishing phases** in order to guarantee good colour processing, materials, finishes, etc.

7.3.1.5. Packaging

Of all the branches of the graphics industry, packaging has suffered one of the smallest declines in productivity. The tangible nature of packaging makes it unlikely to be replaced by multimedia products. Moreover, there seems to be a growing interest in **increasing the quality of packaging**; packing and packaging are growing more sophisticated in terms of the **conception of interesting three-dimensional shapes**, as well as the printing materials and finishes used. Today, software capable of simulating folding sequences and producing rendered images is used in the design phase to imitate the most complex finishing processes before packaging items are actually produced.

7.3.1.6. Printed electronics

In the field of printed electronics, also known as functional printing, researchers develop inks with specific properties (e.g. light-sensitive, organic, conductive) that are capable of lending new characteristics to substrates and which can be used with traditional printing methods. The first examples of this new printing concept arrived with the development of functional labels (such as RFID tags and 2D barcodes) designed to simplify and automate object identification and traceability.

In the field of nanotechnology, researchers are developing **conductive nano-inks** that exhibit good adhesion to flexible media. This technology has great market potential, and its development signals the possible expansion of electronic paper and other applications yet to be discovered.

7.3.2. Digital publishing

As mentioned above, digital publishing is growing at a dizzying rate. All signs indicate that within just a few years the use of multimedia devices to access and handle information will be widespread. To embark on a detailed description of digital publishing would be beyond the scope of this book. Instead, we will describe a few points where digital and print publishing overlap due to the need to convert certain products that were traditionally paper-based to a digital format. **What multimedia products are the direct heirs of print publishing?**

The heirs of catalogues, brochures, magazines, etc.

Some applications enable PDFs to be adapted more or less automatically, providing simulation of page turning to make them easier to read.

7.3.2.1. Cross-media applications

Cross-media applications are among the first examples of **paper-based works being adapted to a digital format**. Graphic designers are receiving a growing number of orders that involve designing and laying out a printed publication and then adapting it as a small PDF file featuring hyperlinks that readers can consult using a computer or other type of electronic device. The order may also involve creating an interactive CD or DVD containing the same information as the paper version. Desktop publishing programs have tools that can handle this type of adaptation and are even starting to make it possible to integrate multimedia content into the PDF files; in addition, there are programs more oriented towards web design that allow the creation and adaptation of multimedia content.

Corporate website of the publisher Index Book

7.3.2.2. Websites, forums and social networks

Today, organisations' websites serve as their letters of introduction , their business cards. A website contains information about a company's structure, history, philosophy, services, (up-to-the-minute) product catalogue, and of course contact information – all in a multimedia environment.

With the advent of Web 2.0, [6] the **points of contact between organisations and users** have gone far beyond mere corporate websites. **Specialised Internet forums** and **social**

The heirs of business cards, informational pamphlets, product catalogues, etc.

6. See 7.1.3.1 page 225

The heirs of newspapers, magazines, fanzines, etc.

Comunidad Macuarium forum specialising in graphic arts

Blog of the magazine Lamono

The heirs of novels, textbooks, etc.

Amazon.com's Kindle

networks are less formal – but no less important – points of contact that provide openings for **new commercial relationships.**

7.3.2.3. Blogs

The advent of **blogs** and **photoblogs** instituted a new form of **periodical publication** – a collaborative form of publication that is updated continually and is open to readers' comments. Following this lead, online newspapers and magazines are based on a different concept than their paper-based counterparts. They resemble websites, with numerous navigation menus, and cooperative blogs where news items are continually being updated and readers post their comments and opinions.

In the same vein, online applications known as **RSS readers** allow users to filter and organise content updates from websites and blogs that use RSS technology. This is **another way of reading periodical publications: the user creates a custom-made publication** that is essentially a compendium of articles from selected sources.

7.3.2.4. E-books

As noted above, the e-book is now a reality. Though this technology is still said to be somewhat rudimentary, the considerable increase in sales signals that the design and production of e-books will be on the rise, with the **digitalization of printed originals**, the **adaptation by means of desktop publishing** of texts that are or have been published on paper, and the **creation of genuinely multimedia content** that encourages interactivity.

7.3.2.5. Interactive publishing

It is no secret that advertising goes where the market is. Therefore, as the public has migrated online, advertising has invested more in the Internet. The result has been significant growth in online advertising: **banners, advertisements that are specialised and personalised** on the basis of the user's

e-mail or social-network account, **viral marketing**, etc. As mentioned above, [7] electronic devices are also starting to be used in outdoor advertising; compared to online advertising, however, this change is coming more slowly due to the costs involved. Although this trend has yet to become the norm, **advertising strategies have indeed shifted** towards innovation and **creativity** as users have grown weary of being subjected to constant visual bombardment.

Apple's iPad

The heir of print advertising, direct marketing (postcards, mailed brochures, etc.) and even, in the long term, outdoor advertising (posters, billboards, wallscapes, illuminated posters, bus shelters, etc.).

Online advertisement for the company www.empleos.clarin.com

Outdoor advertisement for the company Nationwide

7. See 7.3.1.3. page 237

7.4. What if I'm a graphic designer?

Faced with the options for the coexistence of digital and print publishing seen in this chapter, a graphic designer must consider the following question: **How should I position myself in this context?**

In the mass media, readers/viewers had to 'swallow' whatever they were given. Today's users have more control over their informational diet, but the fact that they know how to cook doesn't make them professional chefs.

Today, **any user can create content** (using tools installed on his or her computer: Photoshop, Illustrator, InDesign, etc.) **and distribute it** (by means of social networks, YouTube, etc.). In a sense, the user is taking on the role of the creator. What role, then, does the designer play? Today, the role of the graphic designer goes far beyond that of a mere illustrator who has some technical expertise with the tools of the trade (image-editing, illustration and desktop publishing software). **A graphic designer needs to have much more knowledge than the average user**. The following are some of the **areas in which designers can specialise**:

Printing

Although print production appears to be on the decline, we have seen that the quality of those paper-based publications that do remain tends to be very high, giving rise to very elaborate book objects and high-tech electronic printing. [8] Designers need to be very familiar with the **characteristics of substrates, systems and finishes** in order to know **what creative possibilities are offered** by each one. They also need to know how to prepare documents properly so they can be printed correctly, and be up to the minute on technological innovations.

At the same time, the growth of print-on-demand and the creation of personalised printed objects [9] have forced designers to invent, if not the graphics for these objects, new forms of participation that allow users to become the creators of their own works. Designers need to know how to **manage users' creations** and to make them viable in a simple and convenient way using applications – generally online – that enable users to create their own designs.

8. See 7.3.1.4. page 237 and 7.3.1.6. page 238
9. See 7.3.1.1. page 235 and 7.3.1.2. page 236

Spatial design

A graphic designer's work goes beyond the two-dimensional surface. **The task of designing signage, exhibitions and trade fairs, which involve large-format digital printing,** 👁 [10] has forced designers to learn about **interior design**, especially with regard to managing visitor foot traffic.

Along the same lines, because **packaging design** is on the rise 👁 [11] and containers have begun to take on complex three-dimensional shapes, designers should complement their expertise in print media with basic knowledge of **industrial design**.

Multimedia design

With the progress and expansion of web design and design for electronic devices, graphic designers now have the option of specialising in **multimedia design**. Knowledge about visual language that is specific to the discipline of graphic design – in addition to knowledge about programming, audiovisual media and usability – are necessary for the development of websites, forums, social networks, blogs, e-books, interactive advertising, etc. 👁 [12]

Maintaining a creative outlook

In any event, even if they acquire the specific knowledge required in the various fields mentioned above, designers need to remember that they work in a changing world and must adapt continually. It is no longer enough to be familiar with the tools and to know more than the average user; their work must go further than that. **The graphic designer must be a curious analyst** capable of distinguishing between what is abundant and what is missing, **a visionary of trends** who gets the most added value out of every medium (whether printed or digital), an **enthusiastic inventor** who comes up with new channels for communication, a **manager of knowledge** who builds the user into the publication, a **cultural worker** whose decisions shape the world, and above all a **creative observer who poses questions from a new perspective.**

'True originality consists not in a new manner but in a new vision.'
Edith Wharton

10. See 7.3.1.3. page 237
11. See 7.3.1.5. page 238
12. See 7.3.2. page 239

7.5. Summary diagram 7: Printed vs. digital publication

Another form of publishing

The Internet is changing publications by:

- **Opening new communication channels that**
 - are multidirectional
 - allow immediate access to information
 - shorten distances
 - treat each individual as unique

- **Broadening the concept of publication to include**
 - variability and mutability
 - multimedia
 - a media space that is open to the public

- **Changing the role of viewers/readers to that of users who**
 - find their own personalised spaces
 - are starting to blur the boundaries between public and private
 - are multitaskers
 - are always connected

Publishing for users

The user is at the centre of the design, whether it is intended for the Internet or for print. In all design fields, the following ideas are starting to be applied:

- User-centred and usability-centred design
- Accessibility
- Interactivity
- The design object as an interface

Enabling digital and print publishing to coexist

Print publication

Promoting its tactile aspect

Focusing on the user

- Printed objects
- Print-on-demand & web-to-print
- Book object
- Packaging
- Printed electronics

Digital publishing

- Cross-media applications
- Websites
- Blogs
- E-books
- Interactive publishing
- Etc.

The graphic designer

Must combine knowledge of a wider range of tasks than the average user, including:

- printing
- spatial design
- multimedia design
- maintaining a creative outlook

8. BIBLIOGRAPHY

8.1. Books

Ambrose; Harris. *Print and Finish*. AVA Publishing. 2006.

Avella, Natalie. *Paper Engineering*. RotoVision, SA. 2003.

Baldwin, Roberts. *Visual Communication*. AVA Publishing. 2006.

Bann, David. *The All New Print Production Handbook*. RotoVision. 2006

Beneito Montagut, Roser; Alberich, Jordi; Corral, Albert; Gómez, David; Franquesa, Alba. *Disseny Gràfic*. Universitat Oberta de Catalunya. 2009.

Beneito Montagut, Roser; Blasco Soplón, Laia *Dirección de Arte en Productos Multimedia*. Universitat Oberta de Catalunya. 2009.

Dabner, David. *Graphic Design School*. Quarto Publishing plc. 2004.

Fernández Zapico; José Manuel. *El papel y otros soportes de impresión*. Fundació Indústries Gràfiques. 2004.

Fishel, Catharine. *Mastering Materials, Binding Finishes. The Art of Creative Production*. Rockport Publishers. 2007

Formentí, Josep; Reverte, Sergi. *La imagen gráfica y su reproducción*. Ediciones CPG. 2008.

Frontisi, Claude. *Histoire visuelle de l'art*. Larousse. 2001

García Jiménez, Jesús; Rodríguez, Juan José. *Materiales de Producción en Artes Gráficas*. Aral. 2005.

Gatter; Mark. *Getting it Right in Print: A Guide for Graphic Designers*. Laurence King Publishing Ltd. 2004.

Hembree, Ryan. *The Complete Graphic Designer*. Rockport Publishers, 2006.

Herriott, Luke. *The Packaging and Design Templates Source Book.* RotoVision, SA. 2007.

Johannsson, Kaj; Lundberg, Peter; Ryberg, Robert. *Grafik Kokbok.* Bokförlaget Arena. 1998.

Johannsson, Kaj; Lundberg, Peter; Ryberg, Robert. *A Guide to Graphic Print Production.* Wiley. 2007.

Manovich, Lev. The Language of New Media. The MIT Press, Cambridge, Mass., USA. 2001.

Marín Montesinos, José Luís; Mas Hurtuna, Montse. *Manual de tipografía, del plomo a la era digital.* Campgràfic. 2003.

Perez Roselló, David; Otero, Susana. *Buenas prácticas para diseñadores de productos industriales impresos.* AIDO (Instituto Tecnológico de Óptica e Imagen).

VV. AA. *A Graphic Design Project from Start to Finish.* Index Book. 2010.

VV. AA. *The Little Know-It-All: Common Sense for Designers.* Gestalten Verlag. 2007.

8.2. Other sources

AIDO (Instituto Tecnológico de Óptica e Imagen)

Barcelona Digital Centre Tecnològic

Gràfiques Inpub

Gremi d'Indústries Gràfiques de Catalunya

ID-Soft

IES-SEP Esteve Terradas i Illa. Departament d'Arts Gràfiques

Inklude

MDI Multi Digital de Impresión

Graphispack

Webs

recursos.cnice.mec.es/media/index.html

www.fotonostra.com

www.gusgsm.com

www.unostiposduros.com

www.wikipedia.org

www.wordreference.com

www.printmag.com

www.printernational.org

9. ACKNOWLEDGEMENTS

I must now write the acknowledgements for this book, which I believe is one of the most difficult tasks I have had to do. How can I thank all those who have contributed to making this book a reality in a way that gives them due praise without sounding tacky?

A Chinese proverb says 'the palest ink is better than the sharpest memory', so while I know my memory will not be as reliable as ink, and while I apologise in advance if I've left anything in the ink pot, I'm going to delve into my memory. Let's see what I can find...

I remember the day when Neus rather timidly gave me her business card; the moment when Sylvie, with a friendly smile on her face, sat me down in the meeting room for the first time; the joy as I told my family I was going to write a book for Index Book; the outburst of celebration among my friends when I started the project. I am reminded of the lovely times spent with my colleagues at Gràfiques Inpub, the understanding of my partners at the Graphic Arts department of Esteve Terradas i Illa School, and the recent advice I received from colleagues at the Open University of Catalonia. I think of Núria, Andrea and Eugènia's patience and Tim and Sunsi's meticulousness. I picture PDFs with comments, scrawly handwriting, yellow highlights, coloured post-it notes and e-mails at inconvenient times with encouraging emoticons :-)

Ink may be more reliable than memory, but I'm not sure ink can capture all the sensations behind these and many other times -- euphoria, optimism, weariness, uncertainty, respect, affection, hard work, enthusiasm, teamwork, satisfaction...

THANK YOU for being part of all those times!